THE MED
MENA

Abbeville Press Publishers

New York London Paris

IEVAL
GERIE

Animals in the Art of the Middle Ages

JANETTA REBOLD BENTON

Library of Congress Cataloging-in-Publication Data

Benton, Janetta Rebold, 1945–
 The medieval menagerie : animals in the art of the Middle Ages /
Janetta Rebold Benton.
 p. cm.
 Includes bibliographical references and index.
 ISBN 1-55859-133-8
 I. Animals in art. 2. Art, Medieval. I. Title.
N7660.B38 1992 92-15412
704.9'432 — dc20 CIP

First printing.
Front jacket: Right, *Centaur with Sword and Dragon*, see plate 15.
Left, *Griffin*, see plate 113.
Back jacket: *The Dragon and Beasts Cast into Hell*, see plate 60.
Title page: *Sampson and the Lion*, see plate 112. *The Unclean Spirits*, see plate 96.
Plate 1, page 5: *Feuding Creatures*, detail from *The War in Heaven, Saint Michael
Battles the Seven Headed Dragon*, fol. 20v. Normandy, France, c. 1300–25.
Cloisters Collection, The Metropolitan Museum of Art, New York.
Plate 2, page 6: *Lions with Vines Twisted Around Their Legs*, Capital from
narthex, Cathedral of Santiago de Compostela, Spain, twelfth century.

EDITOR: CONSTANCE HERNDON

PRODUCTION EDITOR: SARAH KEY

DESIGNER: JOEL AVIROM

PRODUCTION MANAGER: HOPE KOTURO

The Medieval Menagerie is dedicated to all who appreciate
the art of the Middle Ages as well as animals, especially unusual animals,
and would be discouraged from keeping a griffin or a dragon as a pet
only by the narrow-mindedness of the neighbors.

CONTENTS

ACKNOWLEDGMENTS

his book derives primarily from a series of five formal slide lectures I presented at the Metropolitan Museum of Art, New York, in the spring of 1988. Information has been incorporated from lectures given at the Smithsonian Institution, Washington, D.C., and Caramoor Center for Music and the Arts, Katonah, N.Y., as well as from gallery talks delivered at the Metropolitan Museum of Art and its medieval branch, the Cloisters. Also included are portions of papers I presented at the 1988, 1989, 1990, and 1991 conferences of the International Congress on Medieval Studies.

I am especially grateful to Hilde Limondjian of the Metropolitan's Department of Concerts and Lectures for making possible the lectures on which this is based, as well as to Nona C. Flores, who co-organized the "Medieval Menagerie" sessions with me at the International Congress on Medieval Studies. She and Haijo J. Westra kindly read drafts of this book. My thanks go also to Marilyn Stokstad and the late

9

Detail of 119 Sense of Taste. Franco-Flemish, Brussels (?), c. 1480-1500. Tapestry. Musée de Cluny, Paris.

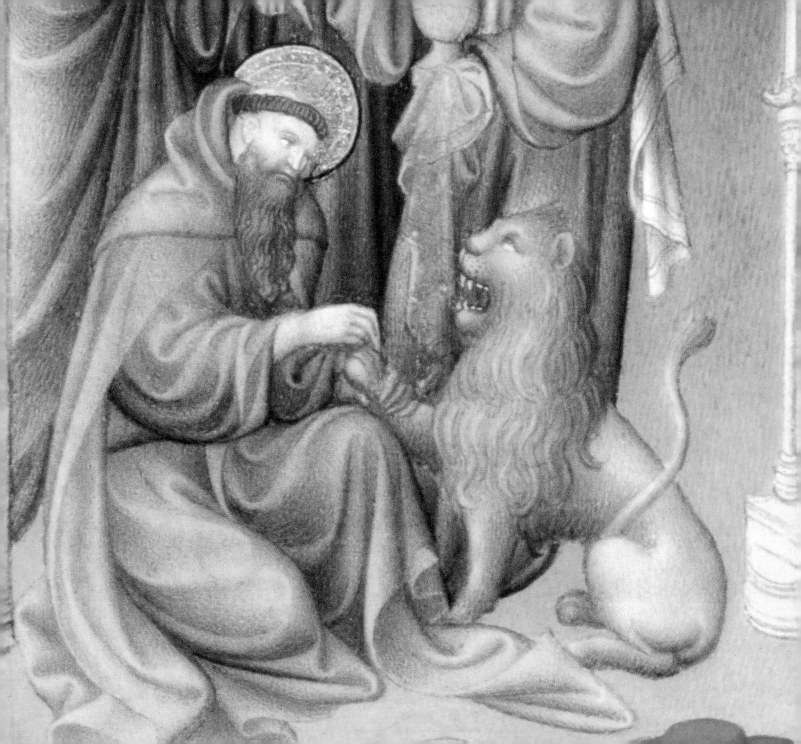

Jerry Stannard for their confidence and encouragement, and to Claudine T. Parisot and Adrian de Roorn for permitting me to use their photographs. I am grateful to Pace University for the financial support that facilitated my research and the purchase of photographs. At Abbeville Press I would like to express my appreciation to my editor, Constance Herndon, whose astute editing greatly benefitted the book, as well as to Amy Handy, Joel Avirom, Sarah Key, and Hope Koturo.

Finally, my greatest thanks go to my family.

11

 Detail of 109 *tory of Saint Jerome and the Lion from the Belles Heures de Jean, Duc de Berry, fol. 186v. Limbourg brothers. French, c. 1410-16. Cloisters Collection, The Metropolitan Museum of Art, New York.*

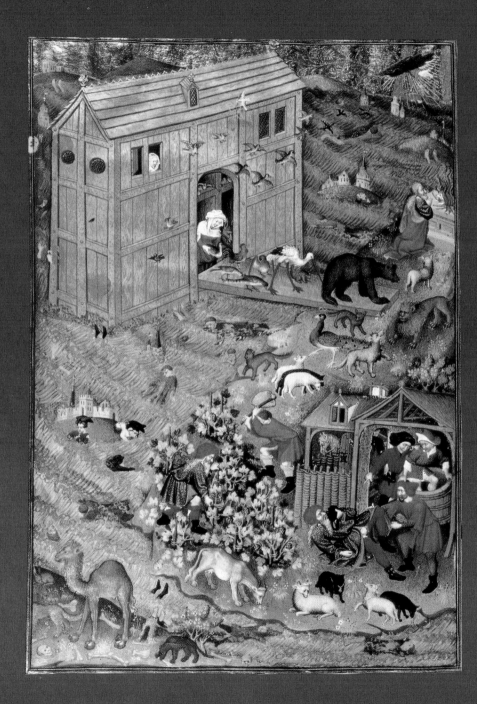

INTRODUCTION

n spite of the centuries that separate the medieval world from the modern world, the art of the Middle Ages maintains an extraordinary appeal to the twentieth-century imagination. Fantastic and fascinating, didactic and decorative, medieval murals, manuscripts, sculpture, stained glass, and tapestries demonstrate the complexity of the medieval mind. Medieval images of our earthly companions, the animals, are especially engaging, for they are able to simultaneously charm, amuse, and instruct. By examining their depiction we can receive remarkable insight into the medieval vision of the world. In particular, the era's attitudes toward the antique past, toward science, and toward the meaning of artistic representation are clarified by an examination of the medieval artists' menagerie.

For the people of the Middle Ages, the origin of the animals was explained in Genesis and was rooted, like all else, in God's work. According to Genesis, all creatures came to Adam to receive their names, an indication of human dominion over the animal world. The ideal environment of the garden of Eden, in which all animals lived

3 *oah's Ark from the Bedford Book of Hours, fol. 16. French, c. 1423. British Library, London, MS. 18850.* ■ *Realistic representation and relative scale are less important here than narrative impact.*

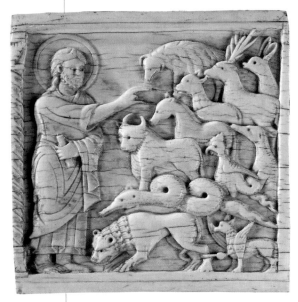

in harmony with one another and with humans, was destroyed when Adam and Eve disobeyed God's commandment by eating the forbidden fruit. According to nonbiblical sources, as a result of the Fall of Man the animals rebelled against Adam and Eve, and although the animals had previously been able to speak to one another in the same language, they were now unable to speak at all.[1]

The animals were to suffer further for human misdeeds. The story is told in Genesis that God was displeased with the sinfulness of mankind. Only the prophet Noah and his family were to be spared from destruction. God directed Noah to build an ark and to bring "two of every living thing of all flesh . . . into the ark . . . male and female." Here the animals endured forty days and nights of rain until the flood waters receded and the ark came to rest on dry land.

The basic story of the animals—created by God, given names by Adam, and saved from the flood by Noah—was greatly embellished by the artists of the Middle Ages, and the variety of animal types was vastly expanded beyond those possibly known to Adam and Noah—or nature.

The seemingly endless kinds of creatures portrayed by medieval artists may be grouped into categories ranging from the familiar to the exotic to the imaginary. At

4 **G**od Creating the Animals. *South Italian, school of Amalfi, late eleventh–early twelfth century. Ivory plaque. The Metropolitan Museum of Art, New York; Gift of J. Pierpont Morgan, 1917.* ■ *God created the lion, horse, bull, ram, deer, and dog—as well as the griffin.*

one end of this spectrum are such familiar animals as horses, cows, dogs, cats, domesticated service animals, and pets. Although artistically rendered with frequency and affection, these animals were perhaps too common to induce excitement.

More interesting to the artists of the Middle Ages were the animals in a second category—exotic or unusual beasts such as lions, camels, and elephants. Although not native to Western Europe, or perhaps for this very reason, these animals appealed strongly to medieval artists. Exotic animals might have been observed in menageries such as those of Frederick II, emperor of Germany and king of Sicily, and Henry III, king of England, but were more likely to be known only via secondary sources such as bestiary and zoological text illustrations or as imagery on items imported from the East.

Equally alluring were creatures in a third category— imaginary and standardized mythological animals such as the centaur, satyr, siren/harpy, triton/mermaid, dragon, and unicorn. All are creatures of antique ancestry whose anatomy was established over the centuries. Except for the dragon and the unicorn, all are part human but were

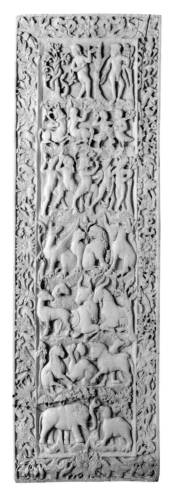

5 *dam and Eve in the Terrestrial Paradise. Reverse of wing of the Consul Areobindus diptych, French, Loire Valley (?), second half of ninth century. Ivory. Musée du Louvre, Paris. ■ Adam and Eve were set to rule over the animal world, their companions including centaurs, sirens, satyrs, dog-headed people, a griffin, and a unicorn.*

regarded as animals. A subsection might be made of those creatures that are part human and part animal but were considered to be races of men, such as the so-called wildmen or the monstrous races of the East, who also had their origins in antiquity.

Most fascinating of all were imaginary and unique animal inventions of the medieval mind. These blatantly bizarre beasts, monstrous marvels referred to here as "composite creatures," were created in the Middle Ages by using the antique technique of disassembling known animals and reassembling their parts in ways unknown to nature. Although the people of the Middle Ages appear to have been genuinely intrigued by animals in general, the beasts that were improbable and even impossible were strongly preferred.[2]

The range of what was considered plausible was quite comprehensive in the Middle Ages. Fabulous creatures such as the griffin, hydra, amphisbaena, serra, remora, phoenix, and many others that are found only in the distant regions of the human mind were accepted, if not as part of the actual animal world, at least as part of the world of exotic fantasy. Among these monstrosities, the ultimate award for impossibility must go to the ant-lion, said to be born of a lion father and an ant mother (which makes the concept of this creature's conception inconceivable).[3]

In defense of the medieval imagination's generosity, however, it must be observed that Mother Nature herself has given us some exceptionally improbable animals. The hopping kangaroo who keeps her offspring in a pouch or the long-necked giraffe both require a stretch of the imagination. Certainly these and many other real beasts are equally as bizarre as the unicorn or griffin, if not more so.

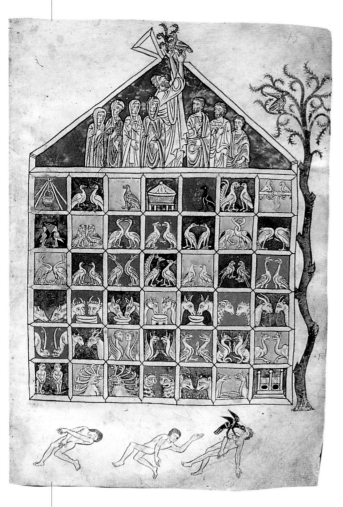

When depicted by the medieval artist or described in medieval literature, all animals, real and imaginary, were presented with equal conviction and credulity, for medieval animal studies were based upon a very different attitude than that held by modern science toward the natural world and toward what is meant by research. Animal imagery was derived largely from secondary sources rather than from direct observation of nature. Direct observation on the part of the artist and experimentation or first-hand experience on the part of the author were not characteristic methods of acquiring information in the Middle Ages.

During these years, compendia of animal information, analogy, and imagery called bestiaries became quite popular. Descriptions of beasts in these books demonstrate that medieval interest in animals was based largely on their usefulness as symbols, particularly for allegorical purposes. The characteristics and

6 *Noah's Ark from the Beatus, fol. 15r. English, second half of twelfth century. John Rylands University Library of Manchester, Manchester, England, MS. 8.*

habits attributed by bestiary writers to both real and imaginary animals were designed to make them effective as moral and religious models.

Yet the bestiary and other medieval sources do not serve to resolve the complex questions that have long surrounded the meaning of animals in medieval art. One animal may well have more than one interpretation, and these may be intentionally contradictory so that a single creature represents opposing sides of an issue; such contradiction was, in fact, an integral and deliberate part of medieval analysis. Caution and common sense suggest that each creature be considered in its own context and that twentieth-century interpretations unknown in the Middle Ages be avoided. When admiring the inventiveness of the medieval artists we must be careful to avoid augmenting it with our own.

18

Opposite 7 **irens *from the* Worksop Bestiary.**
fol. 17r. English, twelfth century.
Morgan Library, New York, MS. M81.

1

ANCESTORS

Fantastic Fauna &
the Medieval Attitude
Toward the Past

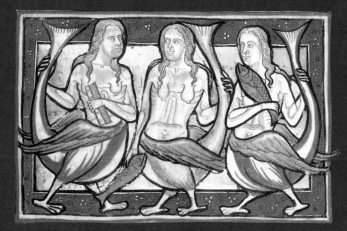

ature provides such a superb supply of animal oddities seemingly sufficient to satisfy the human animal's requirement for variety that the medieval artists' desire to expand nature's repertoire with invented animals might seem surprising. Yet although many kinds of real animals were portrayed by the artists of the Middle Ages, there was apparently some discontent with the limitations of nature's creations. Artists demonstrated a special fondness for creatures that departed from the norm and they used their own methods to multiply greatly the animals included in the medieval menagerie.

The artists' innate inventiveness, displayed in creatures created in different media and styles, was enhanced by beasts from a variety of sources, including the animal interlace of Anglo-Irish manuscript illumination, Barbarian animal style, Byzantine and Eastern sources (especially those known through imported textiles and the work of Muslim artists in Spain), and popular folklore. In particular, however, medieval artists turned to the antique past for animals, notably to the inventions of Greek and Roman art and literature. Using this rich heritage, Western European artists of the Middle Ages became more adept at inventing fantastic fauna than any other group of artists working at any point in history.

Like many other aspects of medieval culture, the depiction of animals during this period demonstrates the strength, persistence, and appeal of the antique tradition, an inexhaustible source of inspiration during these centuries. The intent of this discussion is not to diminish the credit medieval artists deserve for creativity by

8 **Dragon Biting Leaf Tail.** *Capital from portico of Abbey Church at Maria Laach, Germany, twelfth century.* ■ *The foliage on which this dragon feeds is formed by his own tail.*

noting aspects of their art that were derivative. In the Middle Ages the role of *imitatio* in creating art was far greater than the role of originality. The medieval "artist" was usually an anonymous artisan trained from youth in a guild system that emphasized technical perfection rather than iconographic or stylistic innovation. The quest for novelty and invention, so important in our century, would have been quite foreign to the medieval artist's approach to his craft, and he can only be lauded for augmenting his artistry with the ingenious utilization of all available sources.[4]

An excellent introduction to the medieval menagerie is offered by the twelfth-century archway from Narbonne, now in the Cloisters collection in New York (figure 9). Starting at the lower left, the first of the eight carved creatures is the

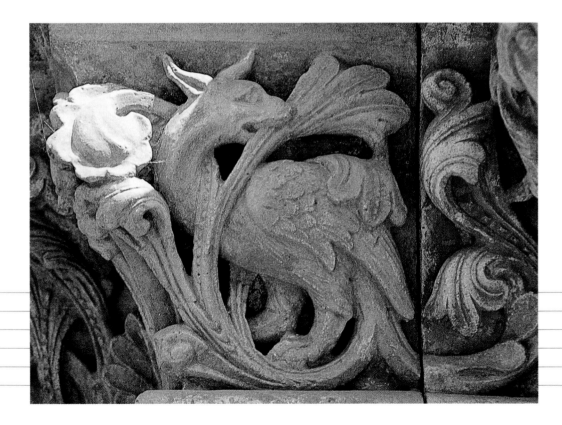

manticore with the body of a lion and the head of a man. His scorpion tail stings and, further diminishing his charm, he fancies feeding on human flesh; his sole salvation is a flutelike voice. The manticore's companion on this arch is the pelican. Although a real bird, she has been given the remarkable ability to bring her dead offspring back to life by pecking at her breast until her blood falls upon them and restores them. While the pelican brings life, her companion on the right, the basilisk, does not. Half bird and half reptile, the basilisk is so lethal that he can kill with a bite, a hiss, a glance, or just his odor. Equally effective but initially less offensive is the basilisk's neighbor, the siren. Half bird and half woman, the siren uses her beautiful voice to entrance her victims before she destroys them. Next is the griffin, a hybrid of the lion, king of the beasts, and the eagle, king of the sky. His neighbor is the amphisbaena, a reptile with a head at either end. Amazingly agile, he is able to move forward or backward with equal ease by putting one head in the other's mouth and rolling along like a hoop. Perhaps less acrobatic but equally impressive is the next creature, the centaur. Half man and half horse, the centaur combines qualities of both—though not necessarily their best qualities. Last on the far right of the arch is the lion; shown crowned, as here, the lion is a medieval symbol of Christ.

9 **anticore, Pelican, Basilisk, Siren, Griffin, Amphisbaena, Centaur, and Lion. Marble arch, probably from the former church of Saint-Cosmus, Narbonne, France, second half of twelfth century. Cloisters Collection, The Metropolitan Museum of Art, New York; John Stewart Kennedy Fund, 1922.**

The creatures on the Narbonne arch are representative of those that inhabited the medieval menagerie. The arch reveals the era's inclination to portray imaginary animals with an antique heritage. Only two of the eight animals on the arch are found in nature—the pelican and the lion—and even these have been made to act in ways they actually do not. Of the six fantastic animals, three—the siren, the griffin, and the centaur—descend from antiquity.

Fantastic fauna appears with particular prominence in ancient art and literature. In one of the most popular stories of antiquity, the Labors of Heracles, nine of the twelve labors required of the hero involve contests with beasts: Heracles fights the Nemean lion, whose skin is invulnerable; the Hydra, with his enormous body, fatally poisonous breath, and multiple heads, one of which is immortal; the boar of Erymanthus; a deer with horns of gold and hooves of brass; the man-eating marsh birds, which have claws, wings, and beaks of brass; the ravaging Cretan bull; the mares of Diomedes, which feed on human flesh; the red cattle, which share the same culinary inclination and belong to Geryones—a winged monster with three bodies who has a two-headed dog; and Cerberus, the three-headed dog with a

10 **D**og with Wings and Serpent Tail.

*Relief from cloister of Notre-Dame,
Le Puy, France, twelfth century.*

dragon tail. As on the Narbonne arch, a majority of these monsters are either entirely imaginary or are real animals that have been given entirely imaginary qualities.[5]

Similarly, animal inventions inhabit Virgil's "world below" in the *Aeneid*. There "monsters crowd—Centaurs, twiformed Scyllas, hundred-armed Briareus, and the Lernaean hydra hissing horribly, and the Chimaera breathing dangerous flames, and Gorgons, Harpies, huge Geryon, triple-bodied ghost."[6]

Many of Heracles' adversaries and the inhabitants of Virgil's "world below" are what may be called "composite creatures." Invented by revising nature, the results are monsters with several heads or bodies or with odd combinations of parts from different animals. This ancient method of expanding the animal kingdom produced a variety of monster marvels born not from the female of the species but from the far more fertile human imagination.

The entire inventory of animal amalgamations invented in antiquity did not survive into the Middle Ages. Some of the composite creatures found in ancient art and literature, such as the Minotaur with the head of a bull, Medusa with her hair of snakes, Pegasus the winged horse, or the sphinx with lion body, bird wings, and human head, largely disappeared during the Middle Ages.[7] Survival of specific species was selective. Some composites found in ancient art, such as the centaur, satyr, siren, triton, and dragon, were to flourish in the culture of the following centuries and were frequently portrayed by medieval artists.

A favorite composite creature of ancient and medieval artists is the centaur or hippocentaur. According to the artists of antiquity, the centaur comes in two versions.

A complete human figure may be shown with the back half of a horse attached at the spine (figure 11). Alternatively, a later and more popular type has a human torso in place of the horse's neck and head (figure 12). A variation is the onocentaur, which joins the top half of a man to the body of an ass.

Early writers described centaurs as followers of Dionysus, the god of wine, and Eros, the god of love. The story of the drunken, lustful centaurs breaking in on the wedding feast of Pirithous, leader of the Lapiths, attacking his bride, and the resulting battle, was told in the tenth century B.C. by Homer in his *Iliad* (I, 268) and *Odyssey* (XXI, 295f.) and by Ovid (43 B.C.–A.D. 17) in the *Metamorphoses* (XII).[8] However, according to the *Iliad* (XI, 832), a highly cultured and skilled centaur by the name of Cheiron,

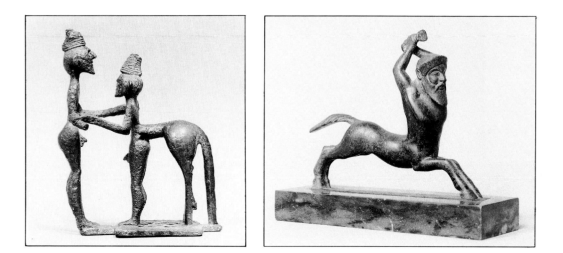

11 **entaur and Man. Greek, said to be from Olympia, eighth century B.C. Bronze.**

The Metropolitan Museum of Art, New York; Gift of J. Pierpont Morgan, 1917.

12 **Centaur. Etruscan or Campanian, sixth century B.C. Bronze.**

The Metropolitan Museum of Art, New York; Gift of J. Pierpont Morgan, 1917.

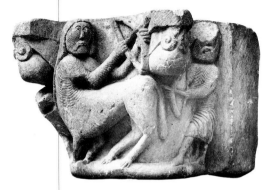

teacher of many of the Greek heroes, was an exception to the usual barbarity of centaurs. Cheiron, wounded accidentally by his friend Heracles and suffering great pain, renounced his immortality and was placed by Zeus among the stars as the constellation Archer (Sagittarius—bowmen in the Roman army were called Sagittarii). The zodiacal period from late November to late December is frequently represented by the archer in the form of a centaur armed with bow and arrow.

The plausibility of the centaur's composite physique was already questioned in antiquity. The Roman poet Lucretius (c. 98–55 B.C.), in *De Rerum Natura* (*On the Nature of Things,* V), observed the troublesome fact that the centaur's two parts would have different life spans, the horse portion reaching full maturity while the human portion was still a baby. Further, one half would have died of old age while the other half was still in its prime!

Like their ancient predecessors, medieval authors were fascinated with the implications of the centaur's biform body, which allowed him to combine the qualities of man and horse. The centaur resembled man in his intelligence, which enabled him to fashion weapons such as the sword or bow and arrow and allowed him to feel emotion —the centaur can cry. And he resembled the horse in his swiftness, sureness of foot, and lustfulness. Like his ancient ancestor, the medieval centaur was said to be fond of wine and women—but not of song, since he could utter only animal sounds.

13 **Centaur with Bow and Arrow. Southern French or northern Spanish, last quarter of twelfth century. Limestone capital. The Metropolitan Museum of Art, New York; Rogers Fund, 1921.**

Opposite 14 **Centaur. Coptic, sixth century. Wool and linen textile fragment. Musée Historique des Tissus, Lyon, France. ■ Transmission of ancient animal imagery to the Middle Ages may have been aided by intermediaries such as this easily transported textile.**

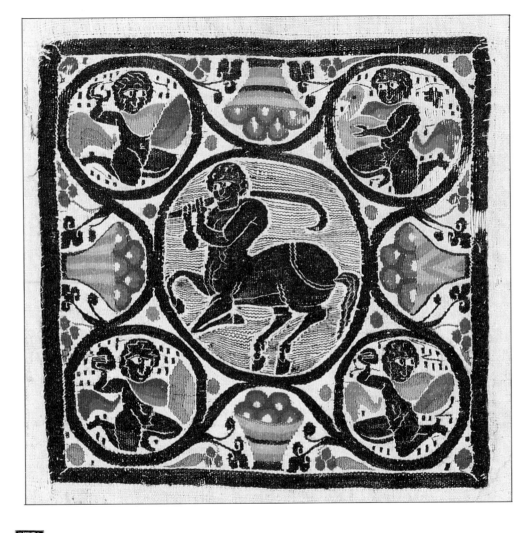

Overleaf 15 entaur with Sword and Dragons. *German, Hildesheim, thirteenth century.*
Bronze aquamanile. The Metropolitan Museum of Art, New York; Rogers Fund, 1910.
■ A metal vessel usually in the form of an animal, the aquamanile held water for washing
the hands either of a priest during mass or of family members before mealtime
(this being an era when forks were a rarity and eating was usually done with the fingers).

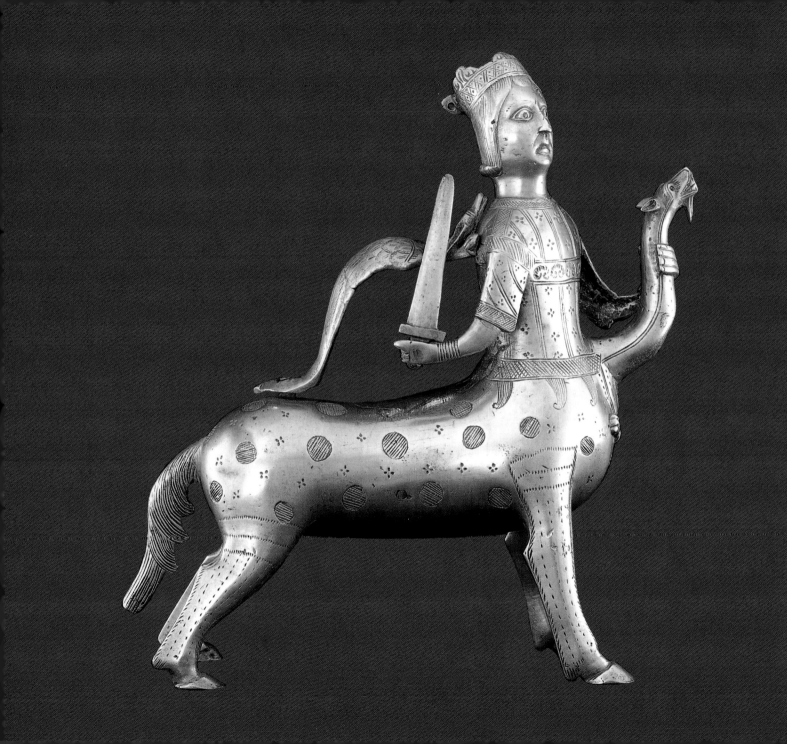

Because he is composed of two very different natures, the centaur was used to symbolize man's internal struggles of reason versus passion or of good versus evil. But the centaur could also be interpreted in wholly negative terms to represent savage passions and especially the crime of adultery as well as brute force, vengeance, and heresy. As such, this creature represents one of several cases in which an animal invented in pagan antiquity came to play a role in Christian iconography. This degree of adaptability will prove to be a key factor in determining which of the fabled animals of antiquity were permitted to persist into the Middle Ages and which were not.

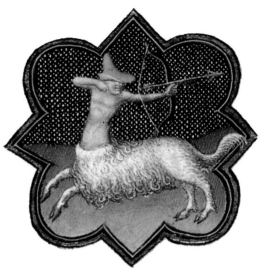

The ancient centaurs produced diverse descendants in medieval art.[9] Those in

figures 13, 16, 17, and 21, like the sagittarii of antiquity, hold a bow and arrow, and indeed many of the centaurs in medieval art represent the Sagittarius of the zodiac. The English word *zodiac*, like the French *zodiaque*, derives from the Greek *zodiakos*, or "circle of animals," directly translated in German as *Tierkreis*. Medieval artists frequently depicted the zodiac in prayer books, as can be seen in the calendar page illuminated by the Limbourg brothers in the *Belles Heures de Jean, Duc de Berry* (figure 17),

 16 *agittarius. Relief from narthex, Sainte-Madeleine, Vézelay, France, twelfth century.*

17 Detail of Sagittarius, calendar page for November from the Belles Heures de Jean, Duc de Berry, fol. 12r. Limbourg brothers. French, c. 1410–16. Cloisters Collection, The Metropolitan Museum of Art, New York.

or on churches, such as that at Sainte-Madeleine in Vézelay (figure 16). Each month in the annual cycle is represented by a different animal and in most cases Sagittarius is represented by the centaur. In this way the ancient mythological creature came to be a frequent image in the medieval Christian environment. It may be worth noting that other than the centaur all the creatures that appear in the zodiac are real: Pisces is represented by the fish, Aries by the ram, Taurus by the bull, Cancer by the crab, Leo by the lion, Scorpio by the scorpion, and Capricorn by the goat.

The centaur also appears in the story of Saint Anthony (c. 251–356—an amazing total of 105 years), told by Saint Jerome (c. 341–420) in his *Vita Pauli Eremitae (Life of Paul the Hermit)* and repeated by the Spanish theologian Isidore of Seville (c. 560–636) in his *Etymologiae (Origins,* XI, 31, III, 21). While traveling through the Egyptian desert to visit Saint Paul the hermit, Anthony meets a centaur. The beast gives him directions to Paul's cave, pointing and speaking imperfectly, and then runs away, an encounter illustrated in the Limbourg brothers' manuscript, the *Belles Heures de Jean, Duc de Berry* (figure 18).

In Isidore's story, Anthony next meets a satyr who offers him dates from a palm tree. Like the centaur, the satyr is a beast of ancient origin, part human and part animal, although here the animal is a goat. Satyrs are usually portrayed with goat ears, perhaps short horns, a long or short tail, and goat hooves or even a goat's lower half. The Greek satyrs, equivalent to the Roman fauns (figure 19), appear frequently in ancient art and literature. These sprightly spirits live in woods and mountains by tending cattle and hunting.

18 **Saint Anthony and the Centaur from the Belles Heures de Jean, Duc de Berry, fol. 192r. Limbourg brothers. French, c. 1410–16. Cloisters Collection, The Metropolitan Museum of Art, New York.**

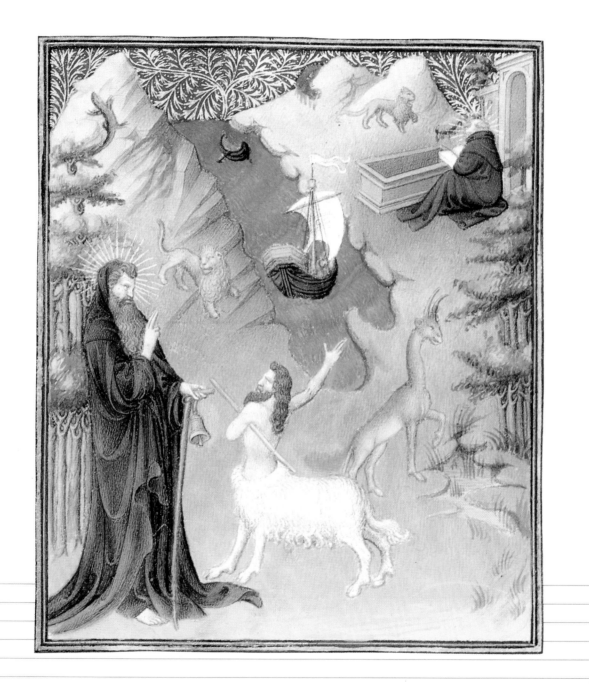

31

Pliny the Elder (A.D. 23–79) notes in his *Naturalis Historia* (*Natural History*, VII, 2) that satyrs are greatly attracted to women and wine. As lustful and wanton as centaurs, they are portrayed in ancient art lying in ambush for the maenads and nymphs or dancing with them and making music. Known for their naughtiness, satyrs revel, play pranks, cause mischief, and are general rogues.

In some respects, although not all, ancient and medieval satyrs are similar. Because of his ancient antics, the medieval satyr came to be used in art as a symbol of evil in general and lust in particular. Although Pliny the Elder says satyrs are so swift that they can be caught only when old or sick, the medieval bestiary explains that satyrs, while cunning, are easy to capture since they live in the open air (figure 20). They are, however, hard to find. Pliny says they live in India, but in the Middle Ages "India" was confused with other countries and came to imply everywhere east of Western Europe.[10] Contradicting Pliny, the bestiaries say satyrs live only in Ethiopia.

Satyrs are also hard to locate in medieval art,[11] for they are not as popular an image as the centaur. But curiously, in the *Belles Heures* the centaur has been given the long fur and the cleft hooves of the satyr (figures 17 and 18). The confusion between the centaur and the satyr and the lack of a precise realm for each creature is demonstrated by comparing the customary centaur Sagittarius of the zodiac cycle at

19 **aun. Roman, early third century A.D. Handle from a silver dish, originally gilt. The Metropolitan Museum of Art, New York; Rogers Fund, 1954.**

20 **Satyr from the Worksop Bestiary, fol. 20v. English, twelfth century. Morgan Library, New York, MS. M81.**

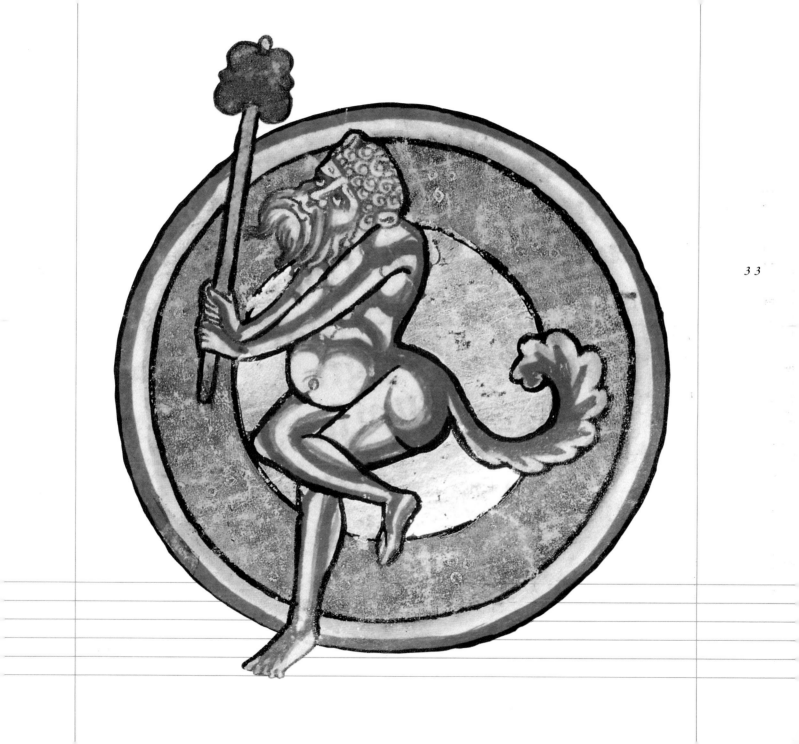

Sainte-Madeleine in Vézelay with the satyr Sagittarius at Amiens Cathedral (figures 16 and 21).

Another composite creature of ancient origin is the siren, a bird with the upper body or head of a woman. She may be shown with wings (figure 22) or without, and may even be clothed (figure 24).[12] The sirens live on an island from which they sing out to sailors on passing ships. Lured by the beautiful songs, the sailors wreck their ships on the rocks, whereupon the sirens pounce on the men and destroy them. Homer describes the sirens as surrounded by the moldering bones of their victims.

Not all sailors fall victim to the sirens. When his boat sailed near their island, Odysseus stopped up the ears of his crew with wax so they could not hear the entrancing songs, but he had himself tied to the mast so he could hear their songs in safety (Homer, *Odyssey*, XII, 41–54, 153–200). Jason and the Argonauts used a different tactic. Protected by the singing of Orpheus, which was even more entrancing than that of the sirens, the Argonauts were able to sail past without harm (Apollonius Rhodius, *Argonautica*, IV, 891f.).

Because of their association with death, sirens are frequently found on ancient funerary objects such as the Roman sarcophagus in figure 24 and especially on monuments to women, poets, and orators. The sirens may be depicted singing a dirge for the dead or used to signify the appealing aspects of beauty and music.

21 agittarius. *Relief from left jamb of left doorway, west facade, Cathedral, Amiens, France, 1220-35.*

22 *Detail of Sirens. Pompeian, from villa at Boscotrecase, c. 11-1 B.C. Fresco. The Metropolitan Museum of Art, New York.*

The siren is similar in form to the harpy, another type of dangerous birdwoman. Mischievous and offensive, the harpies lack the sirens' surface charm, although as goddesses of the storm and symbols of the disappearance of men in bad weather they too bode ill. (Their very name, which comes from the Greek *harpazein*, means to snatch or carry away.) The harpy is described by Hesiod, probably writing in the eighth century B.C., as a winged female, although in later literature she is said to be half bird and half woman.

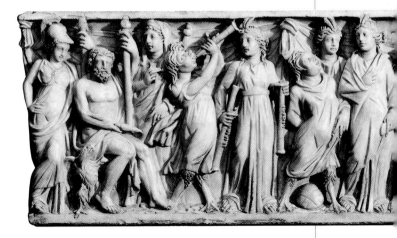

The ancient siren or harpy reappears with some frequency in the Middle Ages.

Reflecting Homer's warning that death would be the result of listening to the siren's song, the medieval bestiary (figure 7)[13] explains that the siren's story is symbolic of the way "ignorant and incautious human beings get tricked by pretty voices, when they are charmed by indelicacies, ostentations and pleasures, or when they become licentious with comedies, tragedies, and various ditties. They lose their whole mental vigour, as if in a deep sleep, and suddenly the reaving pounce of the Enemy is upon them."[14] The siren is used in medieval art as a symbol of deception, temptation, and the fall of mankind from God's grace.[15]

23 **Siren. Relief from cloister of Notre-Dame, Le Puy, France, twelfth century.**

Center 24 **Musical Contest Between Sirens and Muses. Roman, second or third century** A.D. **Marble sarcophagus. The Metropolitan Museum of Art, New York; Rogers Fund, 1910.**

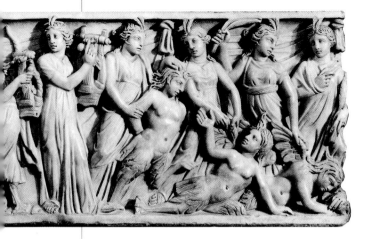

In both ancient and medieval times significant confusion arose over the correct construction of the siren's body. The Hellenistic siren was sometimes given the form of a mermaid, although her lower half was that of a fish rather than a bird, possibly to indicate that she was fathered by a sea god, and in early bestiaries a mermaid with a fish tail is also called a Syren. Likewise the tails of the green-winged sirens in the *Worksop Bestiary*

(figure 7) end as fins rather than as feathers, and two of the three sirens hold fish.

A number of further variations on the siren were devised. According to Philippe de Thaon's early twelfth-century bestiary, the *Livre des Créatures (Book of Beasts)*, the siren has bird feet but a fish tail and sings a song that puts boatmen to sleep.[16] Guillaume Le Clerc, in his early thirteenth-century rhymed bestiary, describes the siren as a beautiful woman from the waist up with a lower part shaped like either a bird *or* a fish.[17] In his mid-thirteenth-century *Le Bestiaire d'Amour (Bestiary of Love)*, Richard de Fournival says there are three kinds of sirens: two are half woman and half fish, the other is half woman and

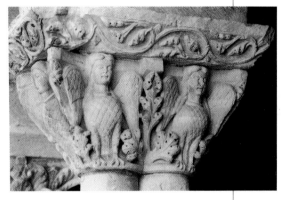

25 **irens. *Capital from cloister of Santo Domingo, Silos, Spain, twelfth century.***

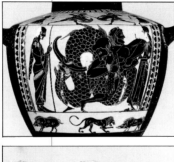

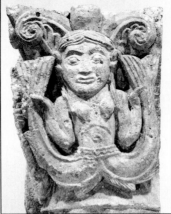

half bird, and all three make music—one with trumpets, another with harps, and the third by singing.[18]

Ambroise Paré, however, notes a gender distinction in his sixteenth-century *Des Monstres et Prodiges (On Monsters and Marvels)*. In the section on marine monsters he explains that there are "men from the waist up, called Tritons, others women, called Sirens, who are covered with scales, as Pliny describes them."[19] The ancient Triton (figure 26), the male counterpart of Tritonis the mermaid, is the son of Poseidon and Amphitrite, rulers of the sea. Triton's upper body, like that of the centaur, satyr, and siren, is human, but the lower half is that of a fish with one or two tails. In time, the number of tritons increased and their description grew more detailed. Pausanias's *Description of Greece* (VIII, ii, If.), written in the second century A.D., says tritons can speak like humans, although they usually are shown communicating by blowing through drilled shells.

Throughout antiquity and the Middle Ages tales of the triton/merman and the tritonis/mermaid or nereid multiplied, as did descriptions of their sightings at sea. But they were also to be seen on dry land, often carved in stone and wood. By creating the mermaid's image in churches, medieval artists seem to have done what they could to accommodate the claim that the mermaid longs to have a soul.[20]

In general, however, the image of the mermaid in the church

26 riton. *Greek, sixth century* B.C. *Black-figure hydria. The Metropolitan Museum of Art, New York.*

27 Mermaid. *Capital from San Martin, Fuentiduena, Segovia province, Spain,
second half of twelfth century. Cloisters Collection, The Metropolitan Museum of Art, New York;
on loan from the Spanish government.*

28 Triton. *Capital from cloister of Sainte-Foy, Conques, France, late eleventh–early twelfth century.*

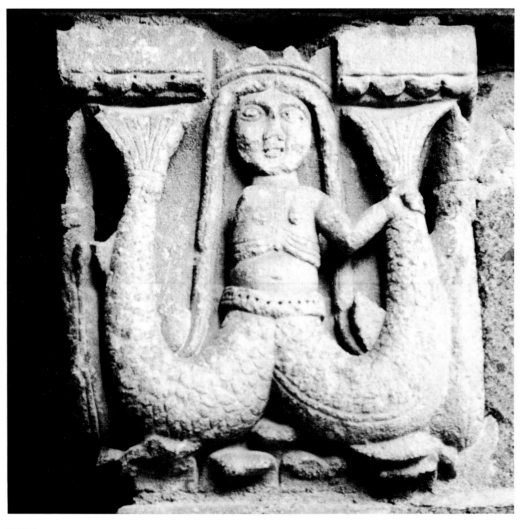

29 **M**ermaid. *Capital from Porche du For, Notre-Dame, Le Puy, France,
late twelfth century.* ■ *Mermaids were generally understood to be
symbols of feminine evils within the ecclesiastical context.*

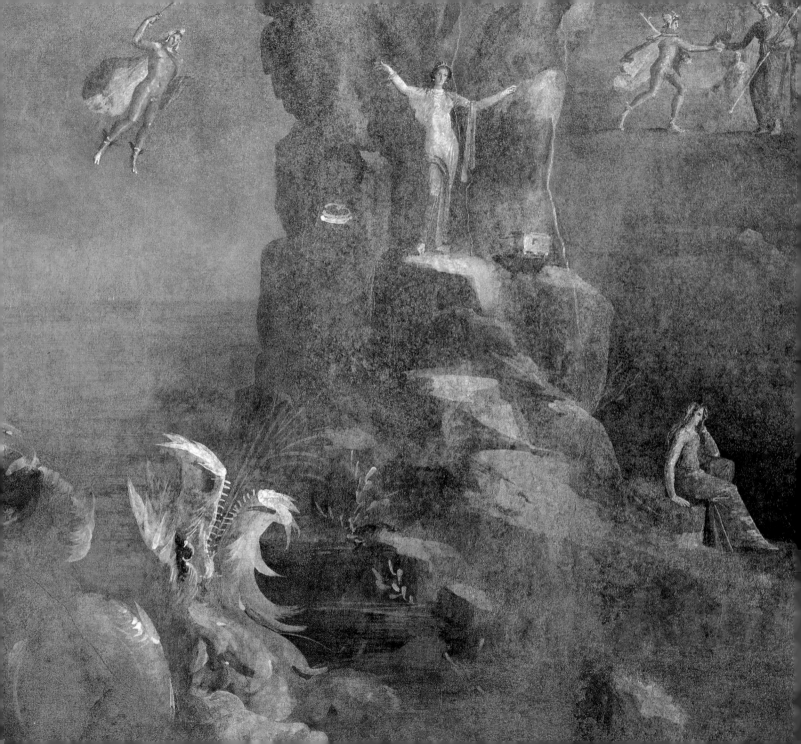

environment has been interpreted unfavorably as a medieval symbol of the evils of the female sex. The mermaid may be shown holding a mirror and comb, emblems of vanity and prostitution, or she may be associated with music, which was suspected of leading to sin in the Middle Ages.[21]

The creature most frequently used in medieval art as a symbol of sin, however, was certainly the dragon. In the ancient story of Perseus and Andromeda, Andromeda's mother, Cassiopeia, boasts that she is fairer than the nereids, and as punishment for her arrogance, Poseidon sends a flood and a serpentine sea dragon. According to the oracle, only one tactic will end these problems: Andromeda (not Cassiopeia!) must

be sacrificed to the monster. A fresco from Boscotrecase (figure 30) depicts Andromeda chained to the rock as she awaits her fate, but the hero Perseus, already in sight, will rescue her at the crucial moment, thereby winning her for his bride.[22]

The serpentine physique of the ancient artist's dragon has a literary equivalent, for the Latin *draco* means dragon *or* snake. At one point Virgil calls the reptile that attacked Laocoön and his two sons a dragon,

30 erseus, Andromeda, and the Sea Monster (Ketos). *Pompeian, from villa at Boscotrecase, c. 11-1 B.C. Fresco. The Metropolitan Museum of Art, New York.*

31 **Dragon.** *Fresco from chapter house of monastery of San Pedro de Arlanza, Burgos province, Spain, c. 1220–30. Cloisters Collection, The Metropolitan Museum of Art, New York.*

but at another it is described as a serpent. This linguistic association appears on a more familiar level with the nonpoisonous snakes kept by ancient Romans as house pets, which were called *dracunculi* (little dragons).

The physique of the medieval dragon, although not firmly fixed, usually includes a bulbous body, wings, two feet with lion or bird claws, and a long curling tail. The medieval bestiaries explain that the dragon is the largest of all serpents and indeed the largest living thing on earth. Residing in Ethiopia or India, they make fiery heat and have fiery breath. Differing from the ancient dragon, who devours his victim, the bestiaries' dragon's strength is in his tail, which he uses to kill his victims either with blows or by suffocation. The dragon can even kill an elephant, his traditional enemy (figure 69), by lassoing the elephant's legs with his long tail, twining it and even his entire body around the elephant, and causing him to suffocate. But the elephant is

Dragon Swallowing a Man. German, late *twelfth–early thirteenth century. Bronze aquamanile. Cloisters Collection, The Metropolitan Museum of Art, New York.* ■ *This dragon obligingly curls his tail to provide a handle for the pitcher.*

avenged, for as he collapses his great weight crushes the dragon.

The poor public image suffered by the dragon/serpent of antiquity can be found in Genesis, too, where he is the creature selected to tempt Adam and Eve to disobey God's commandment. Based upon this biblical vilification, medieval iconography utilized the dragon as a symbol of

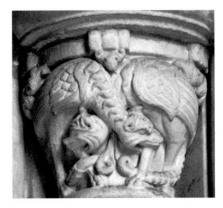

 33 Dragons Biting Legs. *Capital from narthex, Cathedral of Santiago de Compostela, Spain, twelfth century.*

34 **Dragons Biting Tails.** *Capital from Saint-Pierre, Aulnay, France, twelfth century.*

■ *These three examples (figures 32, 33, 34) from Germany, Spain, and France, demonstrate the diversity of the medieval dragon's domain—and diet.*

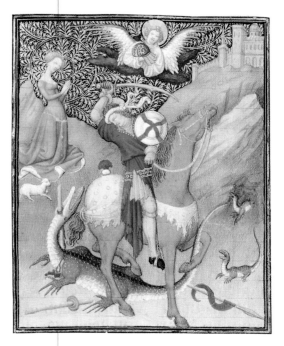

evil and particularly of heresy. For example, the Order of the Vanquished Dragon, established in 1418, employed the image of the conquered dragon as the symbol of heresy overcome.

The life stories of numerous saints also include the defeat of a dragon to symbolize the triumph of good over evil, of Christianity over paganism or Satan.[23] Saint Margaret of Antioch is swallowed whole by Satan disguised as a dragon, but the cross she carries becomes enormously enlarged, causing the dragon to split in two and allowing her to emerge unharmed (figure 36). Saint Martha subdues her dragon by spilling holy water on him and then uses her belt like a leash as she leads him away to be killed.

Saint George's dragon (figures 35 and 37) poisons the air with his breath. To placate him, the townspeople feed him their children, who have been selected by lot, until it is the turn of the king's beautiful daughter, Cleodelinda. Fortunately, the heroic George arrives at the crucial moment to save the princess and slay the dragon. According to an alternative version 'of the story, at first he only wounds the dragon; Cleodelinda leads the beast back to town using her belt like a dog's leash (much as did Martha), and George agrees to slay the dragon only when the townspeople agree to be baptized. Understandably,

35 *aint George and the Dragon from the Belles Heures de Jean, Duc de Berry, fol. 167r. Limbourg brothers. French, c. 1410–16. Cloisters Collection, Metropolitan Museum of Art, New York.* ■ *In this version of the story, sheep are first offered to the dragon and only after they run out are children sacrificed.*

36 *Saint Margaret and the Dragon from the Belles Heures de Jean, Duc de Berry, fol. 177r. Limbourg brothers. French, c. 1410–16. Cloisters Collection, Metropolitan Museum of Art, New York.*

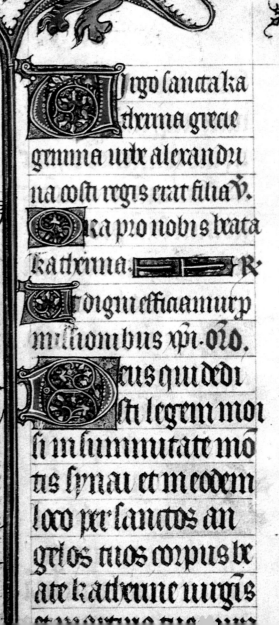

irgo sancta ka
therina grecie
gemma urbe alexandri
na costi regis erat filia v.
ca pro nobis beata
katherina. R
t digni efficiamur p
millionibus xpi. oro.
eus qui dedi
sti legem moi
si in summitate mo
tis synai et in eodem
loco per sanctos an
gelos tuos corpus be
ate katherine virgis

peruenire. per do. no.
De sancta margareta.

ka autem be
ata margari

many are said to have been persuaded on that day.[24]

Like the ancient story of Perseus and Andromeda, the medieval tale of Saint George and the dragon features a beautiful damsel in distress who is doomed to be devoured by a dragon for the public good but is rescued by a brave hero only moments before. The Saint George story demonstrates how an ancient pagan tale of danger and romantic adventure could be rewritten to accommodate Christian teachings.[25]

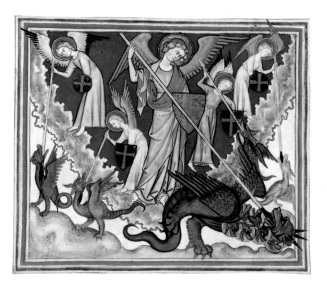

Another battle with a dragon, this one against Saint Michael, is described in Revelation (the Apocalypse), thought to have been written in 95 A.D. by Saint John the Evangelist. The story is richly illuminated in an early fourteenth-century Norman manuscript known as the *Cloisters Apocalypse.* The folio reproduced in figure 38 shows Michael leading a heavenly host of angels to defeat Satan and his followers. The text translates: "And there was a battle

 37 aint George and the Dragon. *German, lower Rhenish, last quarter of fifteenth century. Brass bowl. The Metropolitan Museum of Art, New York; Gift of Irwin Untermeyer.* ■ *The real horse and the imaginary dragon are rendered by the medieval artist with equal clarity, conviction, and credulity.*

38 *The War in Heaven, Saint Michael Battles the Seven-Headed Dragon from the* Cloisters Apocalypse, *fol. 20v. Normandy, France, c. 1300–25. Cloisters Collection, The Metropolitan Museum of Art, New York.*

in heaven; Michael and his angels battled with the dragon. . . . And that great dragon was cast down, the ancient serpent, he who is called the devil and Satan." Within a few lines Satan is called "that great dragon," "the ancient serpent," and "the devil."

The dragon and the other beasts drawn on the pages of the *Cloisters Apocalypse* are among the most menacing as well as mesmerizing of medieval monsters. Revelation remained a popular source throughout the Middle Ages, its apocalyptic visions allowing free reign to the imagination of generations of illustrators, resulting in generations of dragons. Artists of the Middle Ages apparently possessed a special proclivity for repulsive monsters and evidenced an amazing ability to create innumerable species of offensive devils, demons, and dragons.

Although the dragon, along with the centaur, satyr, siren, and triton, was perpetuated in the Middle Ages, other fabled creatures of ancient origin, no more implausible than these beasts, produced no medieval progeny. The explanation for this selectivity seems to be connected with the use that could be made of specific antique pagan animals by religious teaching during the Christian Middle Ages. Simply put, those ancient creatures that could be made to serve medieval religious concepts were

39 **S**aint Michael and the Dragon. *French, late twelfth–early thirteenth century. Champlevé enamel on copper-gilt crozier. The Metropolitan Museum of Art, New York; Bequest of Michael Friedsam.* ■ *Saint Michael attempts to spear a small dragon, but the volute terminates with the head of a larger dragon that seems ready to take revenge—and a bite of Michael from behind.*

readily incorporated into the artists' menagerie, and those that could not, were not.

No conflict was seen in employing a pagan source in a Christian context; rather, the antique heritage was regarded as an available and ample supply of inspiration. Antiquity's bounty might be equated with a sort of "storeroom" from which ideas and motifs could be taken individually without disturbing the next item on the shelf.

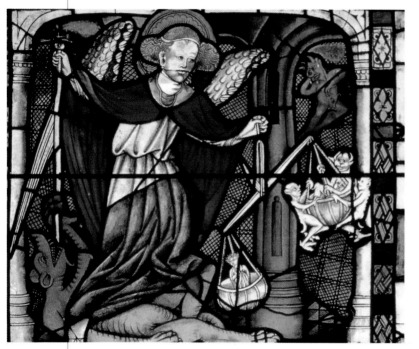

Working with this "motif mentality," the medieval artist could use any single aspect of the antique heritage in isolation, without concern for the connotation the animal carried in the pagan era.

In addition to perpetuating certain antique animals, medieval artists also preserved the ancient technique by which these species had been invented and employed it to create countless new creatures of their own. Though the biologist lacks the means of producing a living specimen of his creative thought in a manner comparable to the horticulturist's ability to

40 *aint Michael and the Dragon. Detail of*
stained-glass window from church of Saint
Severinus, Boppard-am-Rhine, Germany,
c. 1440–47. Cloisters Collection,
The Metropolitan Museum of Art, New York.

produce new strains by grafting branches from one plant onto another, the medieval artist was able to employ this technique of procreation by hybridization with great freedom. His supreme specialty was the creation of composite creatures. Evidently real animals were not regarded as indivisible wholes but as compilations of parts that could be rearranged to create new species. Innumerable nameless creatures were conjured up, giving visual form to the inhabitants of dreams and nightmares. As if in competition to produce the pinnacle of animal implausibility, the medieval pupil easily surpassed his ancient teacher.

Certain medieval monuments are especially rich in composite creatures, such as the rural church of Saint-Pierre in Aulnay, where a multiplicity of these monsters is carved around the south transept portal (figure 42). There animal bodies have been given human or bird heads, bird wings, and tails that even sprout leaves. Intertwined and interwoven, the effect recalls the exquisite animal interlace that ornaments Insular manuscripts such as the *Book of Kells*. At Aulnay the stress is similarly on

41 **T**wo-Headed Bird. *Spanish, twelfth century. Samite textile fragment. Musée Historique des Tissus, Lyon, France. ■ Composite creatures found their way into all medieval artistic media and geographic areas.*

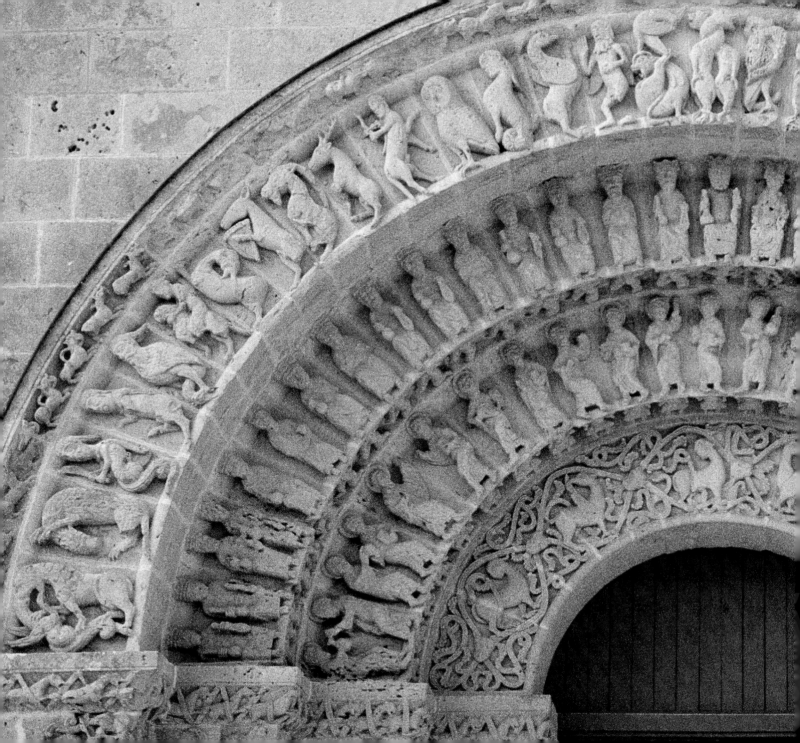

the surface, densely strewn with a pattern of peculiar animals. The carving of these highly animated creatures is more refined than their behavior, for they bite and grimace as they twist themselves into S shapes to conform to the shape of each voussoir. Here are to be found a mermaid, a dragon, and a sphinx (figure 43), all of ancient ancestry, in the company of medieval monsters, demonstrating that animal imagery of any origin was welcomed by the artists of the Middle Ages. Equally as

important as Aulnay to the hunter of hybrids is a second French transept portal, that on the north portal of Rouen Cathedral (figures 44, 45). Countless combinations are possible since human bodies may bear animal heads and animal bodies are allowed to have human heads.

A significant number of composites also appears on a greatly reduced scale in the margins of manuscripts. Here the careful

 42 **Fantastic Animals. South transept portal, Saint-Pierre, Aulnay, France, twelfth century.**

43 **Mermaid, Dragon, Sphinx. Detail of archivolt of south transept portal at Saint-Pierre, Aulnay, France, twelfth century.**

observer will discover extraordinary combinations of creatures, among them those in the *Hours of Jeanne d'Evreux*, illuminated for the queen of France by Jean Pucelle (figure 51); the *Prayer Book of Bonne of Luxembourg*, the work of a follower of Jean Pucelle (figure 142); the *Belles Heures*, created for Jean, duke of Berry, by the Limbourg brothers (figure 36); and the *Cloisters Apocalypse*, illuminated in Normandy by an unknown master (figure 1).

44 **uman Body with Animal Head.** *Relief on north transept portal, Cathedral, Rouen, France, late thirteenth century.*

45 **Human Head with Animal Body.** *Relief on north transept portal, Cathedral, Rouen, France, late thirteenth century.*

46 **Vomiting Gargoyle.** *Apse, Saint-Etienne, Beauvais, France, sixteenth century.*

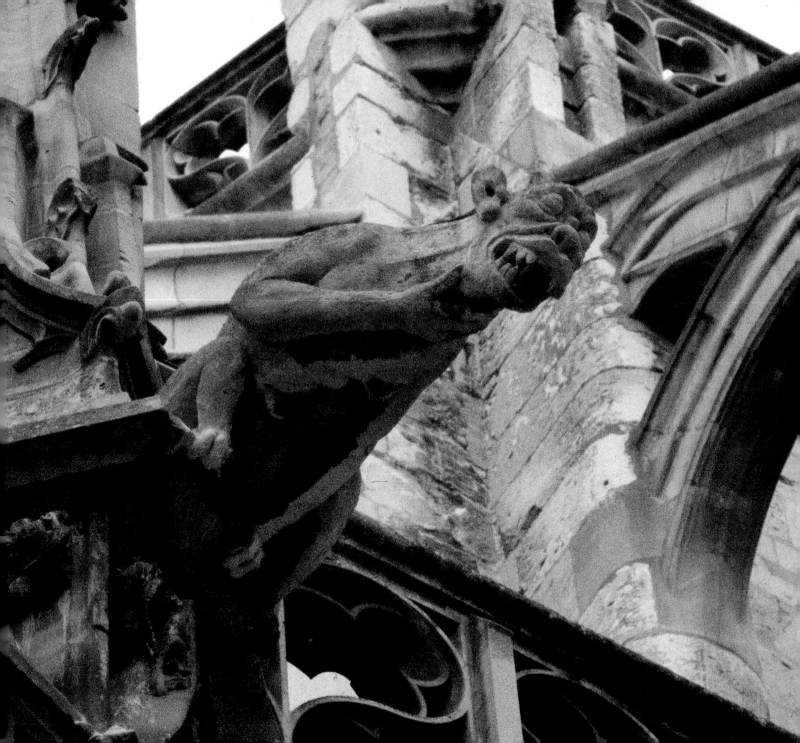

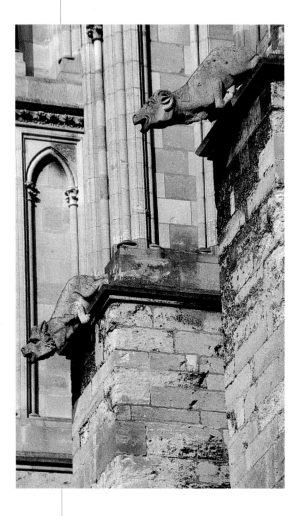

Some especially alluring composite creatures serve as gargoyles. The true gargoyle is a functional fantasy—a water spout that projects from the side of the building to throw the collected rainwater wide of the wall, thereby preventing the erosion of the mortar between the stones. Channeled through a trough carved along the creature's back, the water usually comes out the mouth. Thus, on a sunny day the gargoyle may merely glower down on us, but on a rainy day he spits. The "spitting images" on the front of Poitiers Cathedral or the back of Saint-Etienne in Beauvais (figure 46) become immensely entertaining during a heavy rain, for they grasp their chests and throats as if vomiting something disgusting—perhaps they object to being obligated to drink water in a country that abounds in better beverages. The gargoyles along the side of Reims Cathedral seem to mock the visitors as they disgorge their water upon them (figure 47).

Equally amusing are the gargoyles that surround the cloister garth beside the cathedral at Toul, creatures positioned to appear as if they are eaves-

 47 ocking Gargoyles. *Cathedral, Reims, France, thirteenth century.* ■ *Located as they were in ancillary areas of the church, gargoyles seem to have been freed of traditional artistic strictures.*

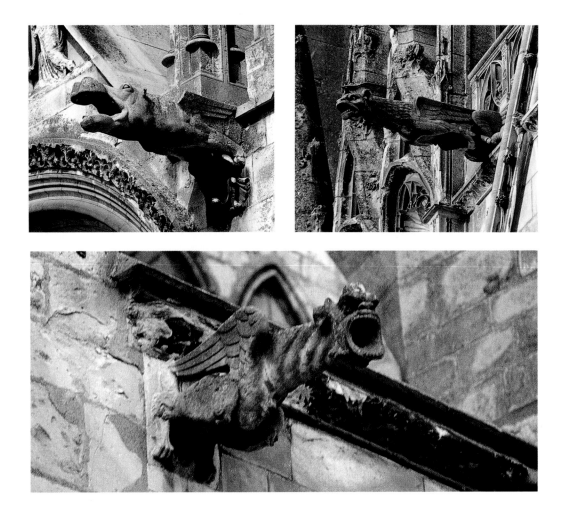

48 inged Hippopotamus Gargoyle. *West facade of Cathedral, Laon, France, early thirteenth century.*

49 Fierce Gargoyle. *West facade of Saint-Etienne, Bourges, France, thirteenth century.*

50 Howling Gargoyle. *South side of Saint-Etienne, Bourges, France, thirteenth century.*

Montes et omnes col
les: ligna fructifera et
omnes cedri. Bestie et uniuersa la pec
ora: serpentes et uolucres
pennate. Reges terre et omnes
ipli principes t omnes

51 **M**onstrous Beast, *detail from the Hours of Jeanne d'Evreux,*
fol. 133r. Jean Pucelle. French, Ile-de-France, 1325–28.
Cloisters Collection, The Metropolitan Museum of Art, New York.

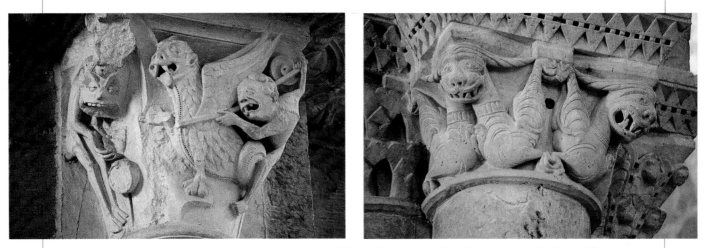

dropping on, or reading over the shoulder of, the monks who sat just below. The winged rhinoceros and winged hippopotamus at Laon Cathedral (figure 48), although certainly unlikely to become airborne, are likely to be the paradigm of paradoxical body parts. Elsewhere, however, many of the monsters that serve as gargoyles have an intentionally menacing mien, such as those at Bourges Cathedral (figures 49 and 50).

Because of their basic architectural function, gargoyles are generally located in ancillary areas, always on the exterior of the church and often in high or otherwise visually inaccessible locations. When carving creatures intended for such positions, sculptors seem to have been freed from many of the iconographic and stylistic conventions characteristic of medieval art. Indeed, gargoyles constitute one of the

52 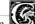ombat of Demons. *Capital from Sainte-Madeleine,*
Vézelay, France, 1120–50.

53 Menacing Monsters. *Capital from Saint-Pierre,*
Aulnay, France, twelfth century.

few areas of medieval art in which artistic license was not severely restricted.

In this respect, comparison might be made between the gargoyles and those creatures that cavort in manuscript margins. The sculptor who carved fantastic gargoyles can perhaps be considered analogous to the illuminator who doodled on the manuscript, for in both cases artistic liberties have been allowed at the peripheries—of the church and of the page. The manuscript illuminator working outside the main illustration of the text, like the sculptor working at the outer edges of the church, could create fantasies largely beyond traditional artistic restrictions.[26]

Perhaps it is this freedom that most distinguished the medieval concept of the composite creatures from their ancient ancestors. The number of composites created

54 **M**onsters Attacking Victim. *Facade portal of Notre-Dame, Neufchatel-en-Bray, France, late fifteenth century.*

55 **Monsters Attacking Another Victim.** *Capital at Saint-Pierre, Beaulieu, France, twelfth century.*

in antiquity, although certainly significant, was essentially fixed and the physiognomies and roles of the creatures standardized. In contrast, medieval artists used their ancestors' methodology to create creatures with an endless variety of bizarre bodily configurations and behavioral deviations. Some of the medieval offspring are frightening or frankly offensive while others are ingenious, amusing, or witty. Few deserve to be described as attractive and none can claim to be pretty.

The potentially repulsive qualities of the composite creature were put to special use. Because of the medieval preoccupation with sin and the general illiteracy of the population, part of the medieval artists' job involved molding public behavior, usually through visual intimidation. At Notre Dame in Neufchatel-en-Bray, a human is

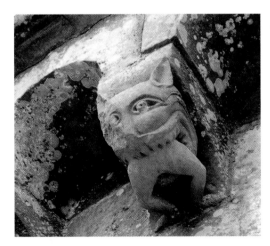

viciously attacked by a monster with beak, claws, scales, feathers, and snakelike tail (figure 54). At Saint-Pierre in Beaulieu monsters gnaw on the head and back of a grimacing man (figure 55), and at Saint-Pierre in Aulnay a beast slowly swallows his human prey (figure 56). Carved outside and inside the church, these creatures embody monstrous sins that endanger the medieval Christian.

Composite creatures provide the intentionally frightening medieval images of

56 **M** **onster Devouring Prey.**
Corbel on east end of Saint-Pierre,
Aulnay, France, twelfth century.

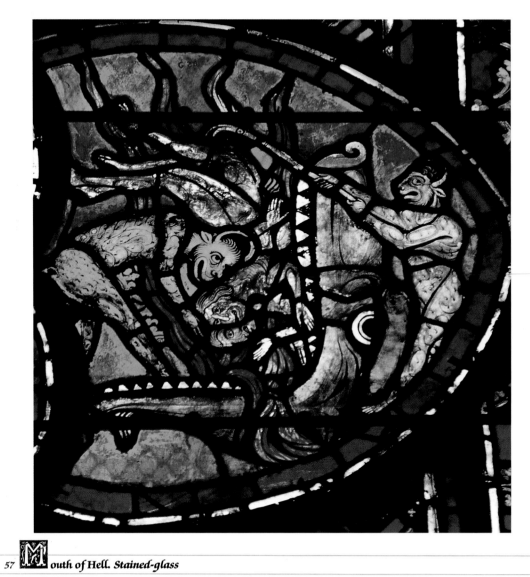

57 **M**outh of Hell. *Stained-glass*
window at Saint-Etienne, Bourges,
France, thirteenth century.

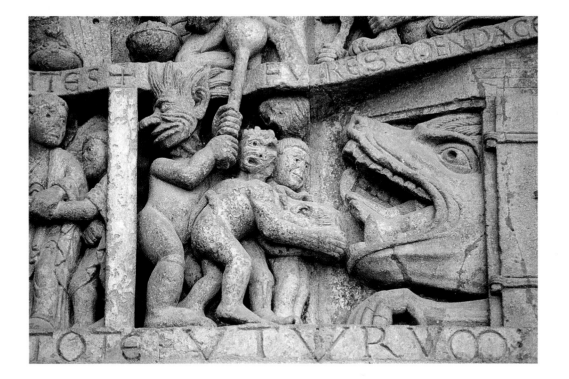

the Mouth of Hell. At Bourges Cathedral and Sainte-Foy in Conques, demons revel in the descent of the damned into the Mouth of Hell (figures 57 and 58), here illustrated as the mouth of a gigantic wolflike animal. In the *Psalter of Henry of Blois* (figure 59) an angel uses a key to lock the damned into an extraordinary double, and doubly monstrous, Mouth of Hell. In the *Cloisters Apocalypse* the dragon and the

58 **M**outh of Hell. *Tympanum at Sainte-Foy, Conques, France, twelfth century.*

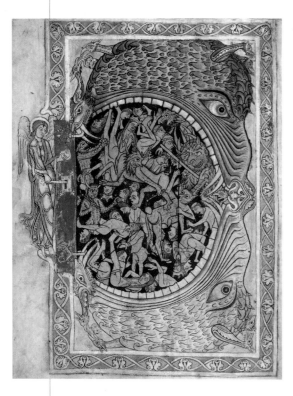

beasts of the apocalypse are shown in the ravening teeth of several Hell Mouths, one of which flashes an evil grin (figure 60). In the lower corner is a gray hairy demon with faces on parts of the body not normally equipped with such features. Perhaps the prime examples of peculiarly positioned body parts on composite creatures are contained within an extraordinary apocalyptic vision at Saint-Pierre in Beaulieu (figure 150). Here one animal has five heads and two extra heads on his tail, and another long curling creature sports small monsters popping out of his back and an additional head on his tail (figure 61).

These monsters, the inhabitants of nightmares made permanent in stone, glass, and paint, were meant to be clear and constant reminders of what awaited the sinner on Judgment Day. The medieval artist depicted the torments of Hell as clearly as possible and spared no effort in maximizing their didactic impact. The images of monstrous animals were intended to encourage the viewer strongly to think twice about the ramifications of his behavior—for it was hoped that if love of God did not deter people from sin, perhaps fear of Hell, as seen in the artists' images, would be more effective.

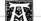

59 ngel **Locking the Damned in the Mouth of Hell** *from the* **Psalter of Henry of Blois**, *fol. 39r. Winchester, England, c. 1150. British Museum, London, MS Cotton Nero C.IV.*

60 **The Dragon and the Beasts Cast into Hell** *from the* **Cloisters Apocalypse**, *fol. 35r. Normandy, France, c. 1300–25. Cloisters Collection, The Metropolitan Museum of Art, New York.*

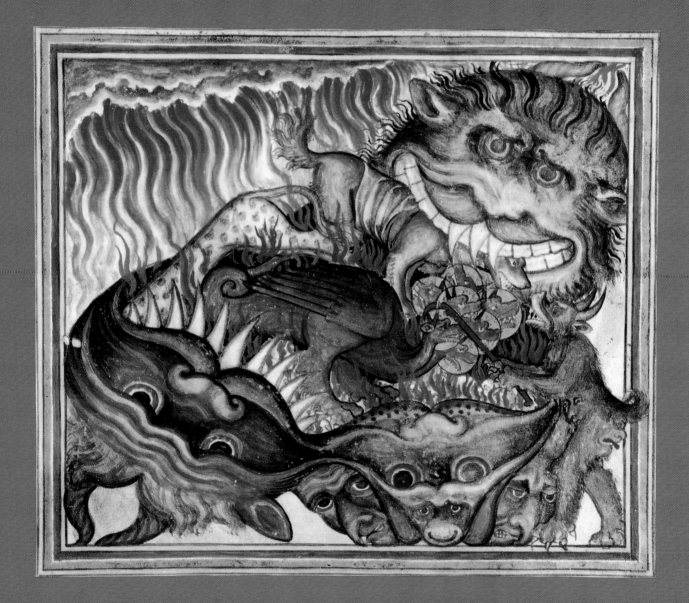

The monstrous composite creatures appeared almost everywhere in the Middle Ages, even invading areas beyond the realm of the painter's brush or the sculptor's chisel. The enormous extent of their domain is demonstrated by their appearance even in medieval cookbooks. These include a recipe for a dish known as *cockentrice*, for which the chef was instructed to construct a composite culinary creature by sewing the front half of a chicken to the back half of a pig.

The intentional search for variety, invention, and implausibility that seems to have guided the fabrication of the medieval menagerie was firmly based upon historical precedent. A number of ancient animal inventions were recast and reused in a medieval Christian context. In addition, by employing the ancient technique through which these creatures had originally been created, medieval artists spawned their own new species of composite creatures. But it was the energy and ingenuity with which medieval artists augmented various sources with their own distinctive genius that gave the medieval menagerie its unique character.

61 **A**pocalyptic Monsters. *Tympanum at Saint-Pierre, Beaulieu, France, 1125–50.*

Opposite 62 **T**erra *from the Worksop Bestiary, fol. 69r. English, twelfth century. Morgan Library, New York, MS M.81.*

2
SCIENCE

Information & Imagery
in the
Medieval Bestiary

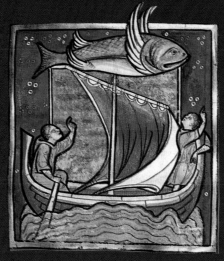

n the subject of the weasel, one twelfth-century version of the popular medieval book known as the bestiary explains, "Some say they conceive through the ear and give birth through the mouth." But this bestiary is quick to say that not everyone believes this: "on the other hand," it points out, "others declare that they conceive by mouth and give birth by ear." The bestiary offers an explanation for this behavior in the form of an analogy to people "who willingly accept by ear the seed of God's word, but who, shackled by the love of earthly things, put it away in the wrong place."[27]

The best source of insight on medieval animal science, the bestiaries are concerned as much with religious teachings and human behavior as they are with animals. Indeed, their emphasis on symbolism and moral edification superseded interest in fact, making the accuracy of the information, or even the actual existence of an animal, of less concern than the beast's didactic usefulness. Medieval authors treated all creatures equally. Whether actual or imaginary, the creature was described with the same degree of conviction and, at times, the same degree of accuracy.

The disparity between the medieval attitude exemplified by the bestiaries and modern ideas about animals is due less to the specific subject of animals than to differing motives for and approaches to intellectual investigation. In the Middle Ages zoology was not a distinct field of study with a recognized methodology. Medieval authors' usual sources of information about animals were the works of earlier authors who were themselves hardly scientists in today's sense. Respect for the ancient Greek

and Roman authors was so great that their ideas, even when obviously outrageous, persisted into the Middle Ages. The apparent medieval capacity for credulity was the result of the largely unquestioned authority of the ancients; if Aristotle said something about animals was so, that was quite sufficient for the "fact" to be repeated by later writers. (It must be understood that this was the accepted research methodology in many fields.) Superimposed on this unquestioning acceptance of the ancients was an outlook on animals that, like so many aspects of medieval thought, was profoundly affected by religious teachings rather than by a concern for verifying information through experimentation or deductive reasoning. Patient observation is all that

67

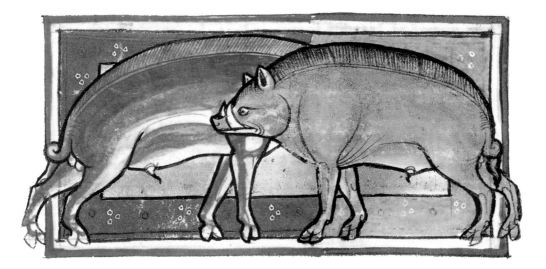

 63 **B**oars *from the* **Worksop Bestiary,** *fol. 36v. English, twelfth century.* **Morgan Library, New York, MS M.81.**

would have been required to close the debate over the weasel's reproductive methods, but the moral lesson of the scientifically false parable was paramount.

The moralistic use of animals, however, has a long tradition that predates Christianity. The enduring appeal of the fables associated with Aesop derives largely from the anthropomorphism of the witty vignettes[28] in which animals with human traits are used to illustrate basic truths about human behavior. Aristotle's *Historia Animalium (History of Animals,* 1) observes that animals differ from one another in character, and describes the behavior of various animals in terms that provide an inventory of human characteristics. The boar is "quick tempered, ferocious and unteachable," the wolf "wild" and "treacherous," the lion "noble and courageous and high-bred," the fox "crafty and mischievous." Aristotle clarifies and categorizes his ideas on human and animal character by bringing them into association, underlining the unity felt by man between himself and the other animals.[29]

Use of animals as subjects for symbolism rather than for science, perpetuated and elaborated by later authors, formed the foundation of medieval concepts about animals. Throughout the Middle Ages it remained common practice to use qualities associated with certain animals to describe things other than animals. The bestiaries explain, for example, that what is wild and rude is described as "boorish" in association with the wild boar, and since the wolf is characteristically "cunning," "greedy," and "rapacious," courtesans who ruin their lovers are called wolves.

Although versions vary, the early bestiaries seem to be fairly straightforward Latin translations of an anonymous late antique Greek compilation known as the

Physiologus (The Naturalist). The original text, now lost, on which the *Physiologus* was primarily based was probably written in the second century A.D. in or near Alexandria. But the *Physiologus* also combines other earlier sources, especially Aristotle, Pliny, Oppian, Aelian, and Solinus, plus information from India, Africa, and Asia Minor. Additional sources came to be incorporated, especially before the year 1000, including excerpts from Isidore of Seville's *Etymologiae,* long considered an authoritative guide to natural history. This seventh-century text, itself based upon earlier sources including the *Hexaemeron* of Saint Ambrose, was concerned with objective facts. In the twelfth century an English author writing in Latin rearranged the creatures into logical categories of beasts, birds, fish, and reptiles. Even more moral allegories and lessons were added and the text was expanded to include over one hundred creatures. At this point about ninety percent of the animals listed were recognizable, but others ranged from the improbable to the absolutely impossible. Combining fact, fantasy, and Christian moral allegory, the *Physiologus* was now known as the bestiary—the book of beasts—taken from its opening words, "Bestiarum vocabulum."

Most of the medieval versions of the bestiary also provided pictures of the animals discussed, whereas versions of the earlier *Physiologus* were only rarely illustrated.[30] The earliest extant illustrated text was made in Reims in the second quarter of the ninth

69

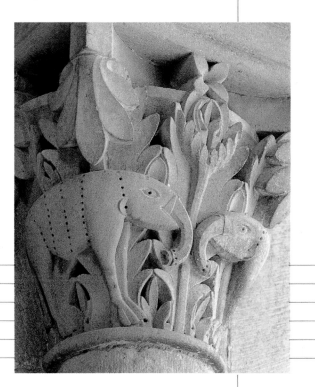

64 **E**lephant. *Capital in the narthex of the former priory of Saint-Pierre et Saint-Benoit, Perrecy-les-Forges, France, twelfth century. ■ The elephant's trunk was compared to a snake in the bestiaries, an observation repeated in the design of this capital.*

century, and is now in the Bürgerbibliothek, Bern (MS cod. 318); the illuminations appear to derive from a late antique model.[31] A small manuscript, bestiaries were widely available in copies made with differing degrees of faithfulness to the text and illustrations. Translated into many languages, they reached their peak of popularity in the twelfth through fourteenth centuries.[32] The illustrated bestiaries became particularly popular in the twelfth century; many examples remain from the twelfth, thirteenth, and fourteenth centuries.[33]

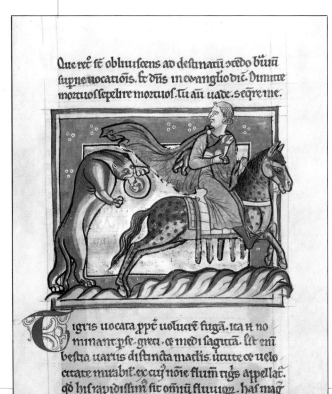

The illuminations in the bestiaries tends to be brightly colored with generous use of red, blue, and gold—colors often far from those selected by nature. Although green and blue monkeys (figure 79) might be explained by the artist's lack of familiarity with monkeys, the same excuse is less acceptable for blue horses (figure 65). Some of the written information in the bestiaries is equally fantastic; indeed data on animals familiar in Western Europe such as weasels, horses, wolves, and stags is only marginally more correct than that on totally invented creatures. Clearly the medieval library had no need for separate "science" and "science-fiction" sections or, more appropriately,

65 **Tiger** *from the* **Worksop Bestiary,** *fol. 35r. English, twelfth century.* **Morgan Library, New York, MS M.81.**

for "natural" and "*unnatural* history." This approach did not persist unchanged; indeed, comparison of the illuminations in twelfth-, thirteenth-, and fourteenth-century bestiaries indicates a general growth in naturalism corresponding with the scientific revival of the thirteenth century.

As for the bestiaries' pictures, they were generally produced by manuscript illuminators and by artists who also worked in other media. The image was sometimes reproduced by pricking the outlines with a series of tiny holes and then, working from the back, pouncing charcoal dust through these holes onto a piece of parchment or heavy paper placed beneath. In this way the bestiaries' imagery could be readily disseminated and become widely influential.

An example of a bestiary volume with especially interesting illuminations is that known as the *Worksop Bestiary* (Worksop Priory), produced before 1187 in England, perhaps at Lincoln or York and now in New York's Morgan Library (MS M.81). The little book measures only 8½ by 6⅛ inches and contains 120 stiff vellum leaves, of which 106 are illuminated. The creatures are grouped as follows: folios 8r–47v are concerned with animals; 48r–68v with birds; 69r–76v with fishes; 78r–89r with reptiles; and 89r–90v with vermin. Within these categories the Latin text discusses each animal individually.

The basic text on each bestiary animal usually consists of two parts. In the first, the etymology of the animal's name is explained, its habitat noted, and its physical characteristics (such as size, color, presence or absence of horns) and habits (such as diet, defensive techniques, speed, temperament) are described. In the second section,

these "facts" are interpreted symbolically to provide the reader with moral lessons.

Among the bestiaries' aberrations of creation, born from the human imagination rather than through natural gestation, is the serra (figure 62). Described as a sort of gigantic fish with enormous fins, the serra is able to fly up out of the sea and over a ship before falling back into the water. The bestiary says: "the ship symbolizes the Righteous, who sail through the squalls and tempests of this world without danger of shipwreck in their faith." But the fish cannot keep up with the ship. The fish "symbolizes the people who start off trying to devote themselves to good works, but afterwards, not keeping it up, they get vanquished by various kinds of nasty habits. . . . You do not get anywhere by starting. You get there by pressing on."[34] Perhaps a real "flying fish" has been enlarged into the fantastic flying serra, invented for the purpose of telling a didactic fish story.

An equally unscientific creature in the bestiaries is the bonnacon. While the serra is essentially an elaboration or expansion of an actual creature, the bonnacon, described in the bestiary as having the body and mane of a horse but the head of a bull, is a true composite creature. The illumination in the *Worksop Bestiary* (figure 66) shows the bonnacon pursued by four hunters, one of whom pierces the animal's side with a spear. The bonnacon can not defend himself with his horns, as the text explains and the illumination shows, because they curl so much that they can cause no damage.

In this case, however, we can save our sympathy for the hunters, for as the bestiary tells us: "however much his front end does not defend this monster, his belly end is

66 **onnacon** *from the* **Worksop Bestiary,**
fol. 37r. English, twelfth century.
Morgan Library, New York, MS M.81.

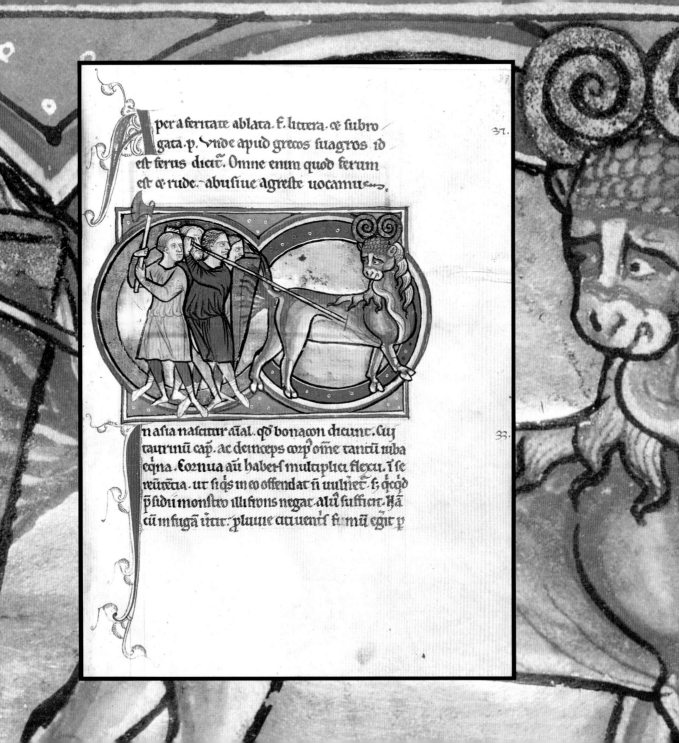

per a feritate ablata. f. littera. œ subro
gata. p. Unde apud grecos suagros. id
est ferus dicit. Omne enim quod ferum
est œ rude. abusiue agreste uocamus.

n asia nascitur aīal. qd bonacon dicunt. Cui
taurinū cap. ac deinceps corp oīe tantū niba
eqna. Cornua aū habers multiplici flexu. ī se
reūetia. ut siqs in eo offendat ñ uulnet. f; qcqd
psidiū monstro illi frons negat. aluū sufficit. Nā
cū in fugā iitit; pluuie cū uentr fimū egit p

amply sufficient. For when he turns to run away he emits . . . the contents of his large intestine, which covers three acres. And any tree that it reaches catches fire."[35] One hunter is shown using his shield to protect himself. Like the serra's aerial ability, the bonnacon's repulsive revenge is an elaboration of actual fact—certain animals do indeed expel the contents of their intestines when frightened. Not surprisingly, the bonnacon's offensive defense is not explained with religious analogy, making him one of the few animals in the bestiary that is not interpreted symbolically.

In contrast to the bonnacon, the imaginary unicorn is exceptionally able to defend himself, not with two curled horns but with one long, straight, pointed horn. A wild, fierce, and beautiful animal, like several other fantastic beasts in medieval art, the unicorn was an invention of the ancients, its earliest written record coming from Ctesias (Itesias), a Greek physician at the Persian court writing about 400 B.C. Aristotle, the recognized authority, also says that there are animals with only one horn in the middle of the forehead, and even Julius Caesar reports an animal having a single tall straight horn on its forehead between the ears. In addition, Pliny the Elder, considered as authoritative as Aristotle, mentions a monoceros (Greek for unicorn), although Pliny's version has feet like an elephant.

Unicorns are usually given white fur and a whitish horn, but the unicorn in the *Worksop Bestiary* (figure 67) has blue fur and a green horn. He is depicted at the lap of a lady and is attacked by two hunters, one armed with an ax, the other with a spear. The bestiary explains that the unicorn can only be caught with the help of a beautiful virgin. Attracted by her purity and scent as she sits in the woods, the

67 nicorn *from the* Worksop Bestiary,
fol. 12v. English, twelfth century.
Morgan Library, New York, MS M.81.

unicorn will put his head in her lap and fall asleep or into an enchanted trance, and only then can he be killed. Although interpretations vary from bestiary to bestiary, the consensus is that the unicorn represents Christ, and the beautiful maiden, through whom the unicorn makes himself vulnerable, represents the Virgin Mary. One bestiary explains: "Our Lord Jesus Christ is also a Unicorn spiritually, about whom it is said: 'And he was beloved like the Son of the Unicorns.'"[36]

So-called unicorn horns were displayed during the Middle Ages at Antwerp, Paris, Venice, Mantua, and elsewhere. The "horn" was probably the tusk of a narwhal, a small Arctic whale similar to a walrus with a long, straight, spiral tusk ending in a

sharp point that conforms perfectly to artistic and literary descriptions of the unicorn's horn. (Of course, perhaps those descriptions conform to the narwhal's tusk.) Sailors coming from the north brought these tusks to Western Europe where they were sold for more than the value of their weight in gold.[37]

The high price was due to the belief that drinking from a beaker made of unicorn horn would prevent death by poison, a notion first recorded by Ctesias. Simple observation of a person with enemies *and*

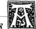

68 *Annunciation with Unicorn. German, lower Rhine, fifteenth century. Bronze bowl.*
The Metropolitan Museum of Art, New York; Collection of Irwin Untermeyer.
■ *The interpretation of the unicorn as Christ is made clear by this depiction of the Annunciation.*
With Gabriel on the left and a Madonna lily, standard symbol of Mary's purity, in the center,
the unicorn presents himself to the seated Virgin.

a unicorn horn beaker might have proved informative on this point, for death after dinner was hardly a rare event in the Middle Ages, the result less of poor hygiene than of deliberate poisonings for political purposes. As poisoners invented increasingly sophisticated potions that did not take effect immediately, advancing hunger allowed the unicorn horn to supersede the official taster at aristocratic tables. Only in the sixteenth century did the story of the unicorn begin to be openly doubted and tests devised to distinguish "fake" unicorn horns from "real" ones.

Belief in the existence of the unicorn was encouraged by confusion of the mythological animal with an actual one. A written or verbal description of a rhinoceros is much like that of a unicorn, the distinguishing feature of each being the single horn in the middle of the forehead. Indeed, the bestiary description of the unicorn says that the Greeks called this animal "rhinoceros." Long before Ctesias there arose an Oriental belief that the rhinoceros horn also provided protection from some diseases and poisons. And, adding to the confusion, Hermes Trismegistus says that the rhinoceros, too, can only be caught by a young virgin.[38]

Skepticism about the existence of the serra, bonnacon, unicorn, and other imaginary creatures was slow to develop, partially since seeing was not required for believing in the Middle Ages. If a fantastic creature could be invented, nothing prevented the imagination from surrounding the creature with equally fantastic habits and abilities. Yet even when the creature described *was* real, not much more restraint seems to have been exercised.

Consider, in this regard, the elephant. Twice depicted in the *Worksop Bestiary*,

69 **E**lephant *from the* Worksop Bestiary,
fol. 78r. English, twelfth century.
Morgan Library, New York, MS M.81.

the elephant appears first in the animal category and later in the reptile category where he is shown being killed by a serpent/dragon (figure 69). The bestiary explains that the elephant is so named because his form and size make him similar to a mountain, *eliphio* in Greek. The nose/trunk is called a *proboscis* ("for the bushes") since it is used to carry leaves to the mouth. Among the actual facts on elephants included in the bestiaries are that they move in herds, have great intelligence, and possess excellent memories. Yet the bestiary also claims that elephants live three hundred years and are frightened of mice. Far worse is the reported lack of joints in their knees, for if an elephant falls down he can not get up again. To solve this problem the animal supports himself while sleeping by leaning against a tree. In order to capture an elephant, the hunter saws partly through the tree so that when the elephant leans against the tree, both will

fall. The notion that the elephant's legs are jointless first appeared in antiquity. Aristotle's *History of Animals* (II.I, 498a, 3f.) says that elephants are *not* jointless, indicating that this was a fallacy sufficiently well accepted to warrant his interest in its refutation. Even during the Renaissance the ability of the elephant to kneel was considered controversial enough for it to be displayed several times.[39]

The mating habits of elephants and other animals seem to have been of special

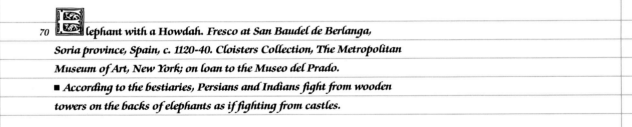

70 ■ *Elephant with a Howdah. Fresco at San Baudel de Berlanga, Soria province, Spain, c. 1120-40. Cloisters Collection, The Metropolitan Museum of Art, New York; on loan to the Museo del Prado.*
■ *According to the bestiaries, Persians and Indians fight from wooden towers on the backs of elephants as if fighting from castles.*

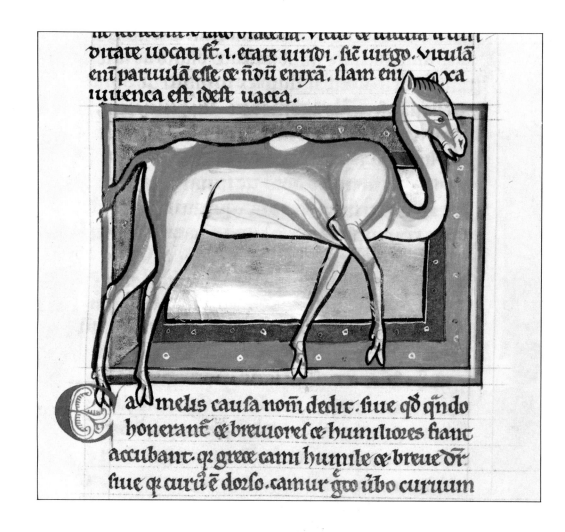

71 Camel *from the* Worksop Bestiary,

fol. 42r. English, twelfth century.

Morgan Library, New York, MS M.81.

interest in the bestiaries. The elephant, they say, has no desire to copulate. Rather, when the elephant couple want a baby, they go to a mandragora (mandrake) tree. First the wife eats from the tree and then she gives some to her husband, after which she is seduced and conceives. Not surprisingly, the elephant husband and wife are said to represent Adam and Eve who were given knowledge when they ate the forbidden fruit and Eve conceived Cain. The implausibility of the bestiaries' description of the elephants' mating method is not due solely to the lack of opportunity to observe real elephants, but grows instead from the preeminence of medieval religious symbolism over science.

Another bestiary animal that is real but not native to Western Europe is the camel. The two-humped camel of the *Worksop Bestiary* is red and white (figure 71). Although the bestiaries explain that other camels, the Bactrians, are stronger and have only one hump, the Arabian camels are more numerous and have two. The bestiaries include other bits of accurate information on the characteristics of camels, which are then interpreted symbolically. Correctly noting that camels can endure thirst and survive for long periods of time without drink, a symbol of temperance, the bestiary explains that when camels *do* drink "they fill up with enough both for past thirst and for whatever lack may come in the future for a long time."[40] The camel prepares for future need, a symbol of prudence, and he will kneel down to accept heavy loads, a symbol of

 72 amel. *San Baudel de Berlanga, Soria province, Spain, c. 1120-40. Fresco. Cloisters Collection, The Metropolitan Museum of Art, New York.*

humility. But because of the animal's "sexual appetite," he is also a symbol of lust.

Among the curious "facts" on camels stated by the bestiaries is their preference for dirty water. If the only water they can find is clean, the bestiaries explain that they stamp in it to "stir up the slime." Although the hearty camel purportedly lives one hundred years, the bestiaries also declare that one sold to a stranger will become ill in disgust at the price.

Another real creature little known to the writers and illuminators of the medieval bestiaries is the crocodile. He is said to get his name from his crocus or saffron color, although the crocodile in the *Worksop Bestiary* is red (figure 73). Despite the declaration that the crocodile is about thirty feet long, the bestiary accurately describes him as amphibious and defended by "horrible teeth and claws," with skin so hard that stones bounce off his back. The crocodile is badly maligned by the bestiaries when his amphibious behavior is interpreted according to moral allegory. His alleged habit of lying in water at night and on land during day is compared to that of hypocrites who live luxuriously by night but are holy and just during the day, pretending to be saintly. The unfortunate crocodile is called a brute, compared to "hypocritical, dissolute and avaricious people," and associated with the "vice of pride" and the "corruption of luxury."[41]

Among the exotic animals included in the bestiaries from the feline family, greatest importance is given to the lion. The bestiary traditionally begins with the lion (figure 74), after which the sequence of creatures is allowed some variation. The lion received this position of honor because he was regarded as the king of beasts in

73 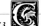 rocodile *from the* Worksop Bestiary,
fol. 70r. English, twelfth century.
Morgan Library, New York, MS M.81.

ocodrillus a croceo colore dict̄. gignit̄
in nilo flumine. animal quadrupes.
int̄ra œ aqua ualens. longitudine
plerūq; xx. cubitoꝛ dentꝯū œ unguiū.
imanitate armatū. Tantacꝗ cutis du

the Middle Ages, just as he had been in antiquity[42] and as he still is today. The bestiary notes: "Leo the lion, mightiest of beasts, will stand up to anybody."[43] In medieval depictions of the story of Noah, the lion is almost always shown as the first animal on and the first animal off the ark.

The bestiaries offer some remarkable information on the behavior of lions. If the lion smells hunters nearby, they explain, he obliterates his tracks with his tail so that he cannot be followed. In this behavior he is like Christ, who was hunted by the devil but was able to elude him. The bestiaries also assert that lion cubs are born dead and remain dead for three days, whereupon the father lion brings them to life. The technique employed depends upon the version of the bestiary one happens to be reading: the father lion either roars at his cubs, breathes on them, or licks them with his tongue as seen in the *Worksop Bestiary*. His life-giving act is interpreted as an allegory of the resurrection of Christ by His Father three days after His death. The lion is also reported to sleep with his eyes open and is therefore an emblem of vigilance. Here the lion is like Christ, whose body was buried and slept while his Godhead remained awake. The bestiary cites the Song of Songs: "I am asleep and my heart is awake," as well as the Psalms: "Behold, he that keepeth Israel shall neither slumber nor sleep." Obviously this description of the lion's habits is based largely upon their symbolic function rather

74 *ion from the Worksop Bestiary, fol. 8r. English, twelfth century.*
Morgan Library, New York, MS M.81.

75 *Unicephalic Lions. Capital from the former abbey of Saint-Gérard, La Sauve-Majeure, France,*
twelfth century. ■ These lions—the curly-maned type the bestiaries assure the reader are peaceful
—willingly share a single head, inverting the old adage that two heads are better than one.

than scientific fact. The desire to illustrate religious teachings with animal analogy resulted in the attribution of amazing qualities to the animals.

Some of the lion's qualities are admirable: he does not become angry unless wounded, preys on men rather than on women, kills children only when very hungry, and spares the prostrate and the helpless. The lion is described as a compassionate creature who displays clemency—a characteristic noted at least as early as Aesop. Some of the qualities are curious: although it is understandable that the lion is frightened by fire and the hunter's spear, it may be harder to accept the bestiaries' statement that the lion is also scared by creaking wheels and by the white rooster or cockerel. Perhaps still more peculiar is the medieval medicinal advice: if a lion becomes sick, eating a monkey will cure him. The bestiaries also note that the sting of a scorpion bothers the lion, and snake poison will kill him.

Conversely, the bestiaries offer the reader some potentially life-saving information about lions. The temperament of a lion can be divined by his physical characteristics: short-bodied lions with curly manes are peaceful (figure 77) but lions with long bodies and straight hair are fierce (figure 78). Further, the bestiary notes that "the nature of their

76 **tanding Lion. North German, Saxony (?), thirteenth century. Bronze aquamanile. The Metropolitan Museum of Art, New York.**

brows and tail tufts is an index to their disposition."
The fierceness of the lion in figure 78 is discernible in his knitted brow and prominent tail tuft. These signs of ferocity, as well as his many pointed teeth, make him especially menacing as he flagrantly paces.

Another feline found in the bestiaries is the tiger. The illumination in the *Worksop Bestiary* (figure 65) shows a tigress being tricked by a hunter who steals her cub. The text explains that the tigress chases the hunter, but when she is close he throws down a glass ball or mirror in which she sees her own reflection and thinks it is her baby. A good mother, she curls around the image in an effort to nurse it—while the hunter escapes with the real cub. "Deceived by the zeal of her own dutifulness, she loses both her revenge and her baby,"[44] says the bestiary. Like so much of the bestiary, this story is found in antiquity,[45] but is given a Christian interpretation: the tiger's tale is interpreted to be analogous to the way the devil diverts people with worldly pleasures.

87

77 **G**rouching Lion. *North Italian, probably Reggio Emilia, twelfth century. Red marble column base. Cloisters Collection, The Metropolitan Museum of Art, New York.* ■ *The bestiaries explain that a peaceful lion can be recognized by his curly mane.*

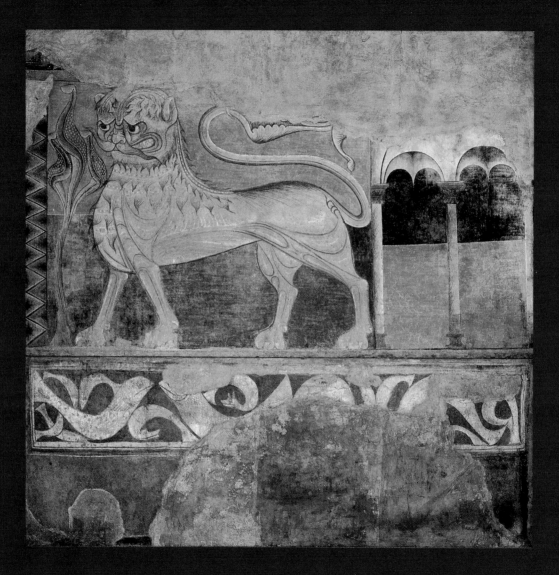

Also among the jungle animals in the bestiaries is the ape or monkey. The *Worksop Bestiary* depicts a mother ape who is attacked by an archer as she carries her babies, one blue and the other green (figure 79). The bestiaries explain that if a monkey gives birth to twins, she strongly prefers one over the other. If she is pursued, she holds

 78 acing Lion. *Chapter house of the monastery of San Pedro de Arlanza. Burgos province, Spain, c. 1220–30. Fresco. Cloisters Collection, The Metropolitan Museum of Art, New York.*

■ *According to the bestiaries, the fierceness of this lion is revealed by his straight fur, brow, and tail tuft.*

79 *Ape/monkey from the Worksop Bestiary, fol. 19v. English, twelfth century. Morgan Library, New York, MS M.81.*

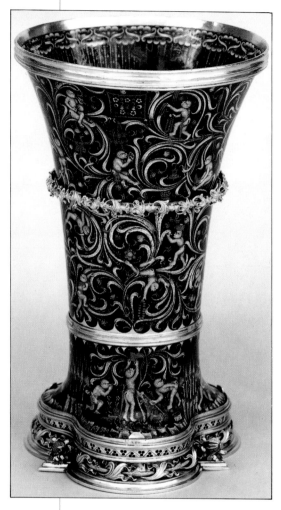

the one she loves in her arms while the one she detests clings to her back. But when she becomes too tired to run on only her back legs, she must abandon the one she loves and is left carrying the one she hates.

The bestiaries note that the monkey has no tail (*cauda*)—an observation that is explained symbolically rather than scientifically: the devil resembles the monkey in that he has no scripture (*caudex*, i.e., codex), and thus the ape/monkey symbolizes base forces, the devil in disguise. The much maligned animal appears in medieval art as a symbol of sin, malice, cunning, and lust.

An allied view of monkeys—thirty-five of them, to be exact—is seen on the celebrated beaker at the Cloisters (figure 80). On the outside of the beaker they rob a peddler as he sleeps, taking his clothes and other possessions, and play in the trees. On the inside they act as hunters and even use hunting hounds as they chase a stag. The medieval artist has portrayed with exaggeration the monkeys' ability to "ape" man's behavior.

Monkeys—like elephants, crocodiles, lions, tigers, and apes—are certainly real animals even though they were not native to the geographic area in which the bestiaries

80 **onkey Beaker. French, Burgundy, c. 1425–50. Silver, gilt, painted enamel.** *Cloisters Collection, The Metropolitan Museum of Art, New York.* ■ *Barbary apes cavort on the outside and inside of the celebrated "monkey cup."*

81 **Dog from the Worksop Bestiary, fol. 28r. English, twelfth century.** *Morgan Library, New York, MS M.81.*

were produced. Perhaps for this reason the information offered is hardly less fantastic than that provided for the fantastic animals examined earlier. The serra, bonnacon, and unicorn were admitted to the bestiaries in spite of the absence of evidence for their existence. Still, they were described with the same completeness and conviction as if the information had been verified by science. Given the way imaginary and exotic animals were treated, it is interesting to see how accurately a familiar animal such as the household dog was described in the bestiary.

The dog is highly praised in the bestiary as the most sagacious and perceptive of animals, the only one who recognizes his own name. The bestiary explains that dogs

venerate their masters, and demonstrates this devotion with the following tale taken from Pliny: A man, while walking with his dog, was murdered by a servant. When the body was discovered and many people gathered around, the murderer joined the crowd and acted as if he, too, mourned. The dog leapt at the murderer, held him tight, and wailed so that everybody was "reduced to tears." The dog's testimony was given such credibility that the murderer was put to torture. At the top of the illumination in the *Worksop Bestiary* (figure 81) the dog identifies the guilty man while on the left the seated judge encourages the crowd to punish the criminal. At the bottom, the dog, ever faithful to his master, remains by his side even though his master is dead.[46] The belief that dogs remain loyal unto death is demonstrated by the representations of dogs at the feet of tomb effigies of women and children (figure 82). Even today "Fido" (the Latin word *fido*) represents trust.

The bestiaries interpret certain of the dog's qualities according to religious analogy.

82 **D**og. *Tomb effigy of a youth (Ermengol IX?), sarcophagus lid, Spanish, first half of fourteenth century. Limestone with traces of polychromy. Cloisters Collection, The Metropolitan Museum of Art, New York.* ■ *Effigies of women and children are often accompanied by dogs, symbols of domesticity and fidelity while men are more often shown with lions, as in figure 108.*

A dog is said to be able to cure a wound by licking it with his tongue (which actually has some truth because of the relative acidity of the dog's saliva). This is compared to the way "the wounds of sinners are cleansed, when they are laid bare in confession." The dog's temperate eating habits are praised in the bestiary, again through analogy: "by no entry can the Enemy take possession of man so quickly as through a voracious gullet."[47]

The bestiaries compare the priest to a watchdog who drives the devil away. Since the cat is often used as a symbol of heresy in medieval art, the meaning is clear of a carving in the cloister at Le Puy in which a dog fiercely bites the tail of a screaming cat-headed human (figure 83). Here the dog protects the church from heretics.

The bestiary information on the dog, although culled from antiquity and interpreted according to religious symbolism, includes several accurate observations on the dog as an intelligent and trainable service animal who can hunt, guard herds

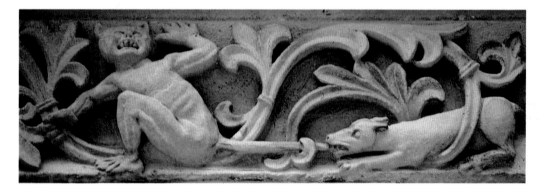

 83 **og Biting Tail of Cat-Headed Human. *Relief from the cloister of Notre-Dame, Le Puy, France, twelfth century.***
■ *This is a portion of a frieze that depicts the dangers that beset the faithful. Here man is transformed into animal as he is defeated by temptations.*

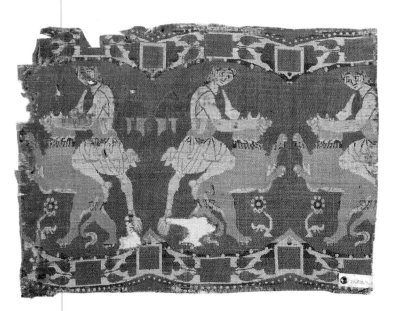

and homes, and is a faithful friend. In the case of the dog, familiarity has enhanced the factuality of the bestiary.

What sources were available to an artist living in medieval Western Europe who wished to depict animals with which he was not directly familiar? For those animals that were fantastic, and for those that were merely foreign to his locale, the artist had access to illuminated bestiaries, zoological texts, and artists' model books.[48] Eastern animals may also have been known in the West via imagery on imported items. Textiles were especially useful in this regard—a piece of silk fabric woven with a pattern of elephants was recorded to have been in Charlemagne's reliquary at Aachen. Some Eastern animal imagery could be adopted and adapted to Western iconography with ease—the Byzantine samite fragment with hunters fighting lions seen in figure 84 is similar to a number of medieval portrayals of Samson fighting the lion (figure 112).

Alternatively, a bestiary illuminator might actually have seen certain exotic animals. The practice of publicly displaying rare animals imported from distant

84 **Hunters Fighting Lions. Byzantine,**
seventh-eighth century. Samite textile fragment.
Musée Historique des Tissus, Lyon, France.

lands dates back to antiquity, when it was not uncommon for emperors, kings, and even wealthy private citizens to keep menageries. On especially important occasions the general public was allowed access to these personal menageries; for example, it is recorded that in A.D. 248 Philip the Arab exhibited elephants, elks, tigers, lions, leopards, hyenas, hippopotamuses, a rhinoceros, lions, giraffes (called *cameleopardi*), and other animals.[49]

The curiosities of the animal kingdom seem to have held great appeal for the ancient Romans,[50] the lion in particular receiving special attention. Used for public entertainment, lions were imported from Mesopotamia, Syria, Arabia, and Africa. Seneca says lions were even tamed and kept in homes as domestic pets, living in and out of their cages. This is not to suggest that time has modified the lion's temperament to the fierceness known today, but rather that the ancients modified their pet lions by removing their teeth and claws.

Although it is known that Charlemagne (crowned emperor in 800) had received an elephant from Harun-al-Rashid, sultan of Baghdad, it is especially from the thirteenth century on that the possibility increased of observing unusual animals in a menagerie. The fashion for menageries was promoted by the emperor Frederick II (1194–1250), whose interest in exotic animals is well recorded: in November 1231 Frederick II brought a menagerie to Ravenna that included lions, leopards, panthers, elephants (with knees), dromedaries, camels, gerfalcons, white falcons, and bearded owls. Hardly one for packing light, Frederick II journeyed to Verona in 1245 with an elephant, five leopards, and twenty-four camels.[51] Little other than Jonah's whale

was ruled out for inclusion in the emperor's extraordinary medieval menagerie.

Evidence of contact with menagerie animals and its effect on artists is provided by the drawings of a lion made by the French artist Villard de Honnecourt. Villard labeled his lion as "drawn from life" (figure 85), and probably one of the lions belonging to Frederick II served as the model.[52] Villard's work includes drawings of animals he recorded out of interest ("curiosities") and renderings meant to serve as models for others to copy. In addition to the lion, Villard drew a snail, a swan, a cat, a grasshopper, a fly, a dragonfly, a lobster, and a porcupine "from life." Although these sketches retain a medieval decorative quality, Villard, unlike his predecessors, actually looked directly at a live subject as he drew.

Villard de Honnecourt's contemporary in England, Matthew Paris, also made drawings from life of an exotic imported animal. King Louis IX (Saint Louis) returned from the crusades with an African elephant, which he gave to Henry III of England in 1255—the first elephant seen in England. This elephant was "drawn from life" twice by Matthew Paris in his *Chronica Majora* during the four years (1255–58) the animal managed to survive the English climate in the elephant house built for it in the Tower of London (figure 86).[53]

The drawings of Villard de Honnecourt and Matthew Paris are evidence of the scientific revival of the thirteenth century. The significance of this revival is perhaps best illustrated by a comparison between the approaches taken to birds. A twelfth-century bestiary, although offering some accurate observations on the temperament, social nature, eating habits, and voices of birds in its introduction, proceeds to relate

85 ion and Porcupine, *sketchbook, pl. XLVIII.*

Villard de Honnecourt. French, 1230s.

Bibliothèque Nationale, Paris. MS. Fr 19093.

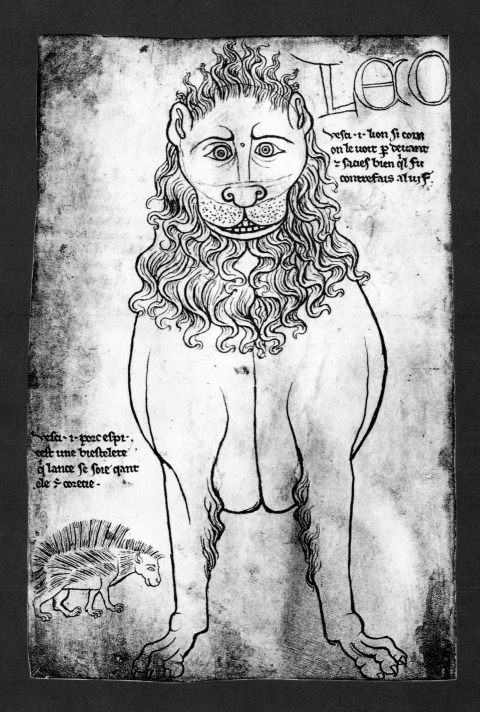

LEO

Vesci .i. lion si com
on le voit p̄ devant
⁊ saciés bien q̄l fu
contrefais al vif.

Vesci .i. porc espi.
c̄ est une bieste lere
q̄ lance se soie qant
ele se corecie .

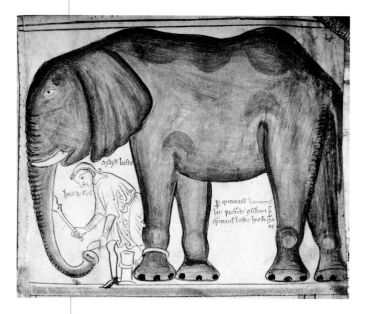

some amazing "facts" in the discussion of individual species: the eagle can rejuvenate himself; the female vulture breeds without a male; the caladrius predicts if a sick person will live or die by facing or turning his back on the patient; the ibis cleans out his bowel with his beak; the unique phoenix lives over five hundred years, whereupon he burns himself on a pyre and rises anew from his own ashes; the partridge can be impregnated by the smell of the male in the wind; the turtledove, if widowed, will forever remain chaste.[54]

Twelfth-century artists were hardly more faithful to fact in their depiction of birds, as evidenced by the enormous bird straddled by a tiny attacking man at Autun Cathedral (figure 87) or the birds with necks that resemble plant tendrils at Sainte-Foy in Conques (figure 88).[55] Scale and proportion have been deliberately distorted by the sculptors to create decorative designs—as freely as contemporary writers distorted fact to create didactic devices.

A very different approach to birds was taken by Emperor Frederick II who, although writing at a time when the bestiaries were extremely popular, offered new and accurate information. A devoted menagerie owner, Frederick II was exceptional

86 *lephant and Keeper from the Chronica Majora, fol. 4r. Matthew Paris. English, 1255–58. Corpus Christi College, Cambridge, M.S. 16.*

87 *Bird Straddled by Attacking Man. Capital from Cathedral, Autun, France, twelfth century.*

88 *Birds with Long Necks. Capital from cloister of Sainte-Foy, Conques, France, late eleventh–early twelfth century.*

in his concern for systematic scientific investigation and data recording. His *De Arte Venandi cum Avibus (The Art of Hunting with Birds)*, written before 1250, is a major treatise on ornithology. Hawking, he said, is the noblest sport, and the text provides a complete guide to falconry with two hundred chapters on practical problems and sixty-three on feeding, mating and nesting habits, migrations, and anatomy. Objecting to the perpetuation of hearsay, Frederick II charged that Aristotle did not verify the ideas found in his sources. Although some of his information did come from Aristotle, Frederick II tested Aristotle's "facts" and repeated only what he verified by his own experience, observation, and experiment. He questioned the bestiary stories and undertook research to affirm or deny their validity. For example, to investigate the bestiaries' claim that the barnacle goose is spontaneously generated from dead trees or rotting wood, he sent envoys to the north to bring back information

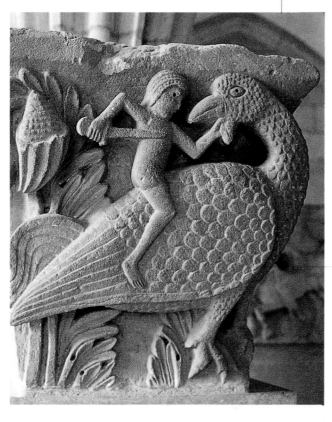

and eventually concluded that the story was doubtful due to lack of supporting evidence.

Frederick II's work on birds forms a portion of a broader thirteenth-century scientific revival. The change in the approach to animal studies is also seen in Bartholomeus Anglicus's encyclopedic treatment of animals, which he arranged alphabetically with the allegories omitted. Brunetto Latini's *Li Livres dou Tresor* includes a bestiary of seventy animals that eliminates the moralization and most of the imaginary animals, although it does only offer information compiled from other authors. Richard de Fournival's *Bestiaire d'amour* secularized the bestiary into social satire and Albertus Magnus, concerned with science as a profane subject, looked to Aristotle rather than to analogy. With the natural world no longer viewed solely to be in the service of God, curiosity about and investigation of nature for itself began to be accepted.

Birds, too, come to be realistically represented by artists. In the Limbourg brothers' sumptuous manuscript the *Très Riches Heures,* illuminated in the early fifteenth century for Jean, duc de Berry, the calendar page for October (figure 89) shows naturalistic birds behaving in a very believable manner—they eat the seed as soon as it is sown and are not at all discouraged by the scarecrow armed with bow and arrow.[56]

The illuminations and text of the medieval bestiaries indicate the accuracy of medieval animal science and the extent to which fact was manipulated to accommodate the symbolic use of animals in religious and moral teachings. This approach

89 **October** *from the* **Très Riches Heures de Jean, Duc de Berry, fol. 10v. Limbourg brothers. French, early fifteenth century. Musée Condé, Chantilly.**

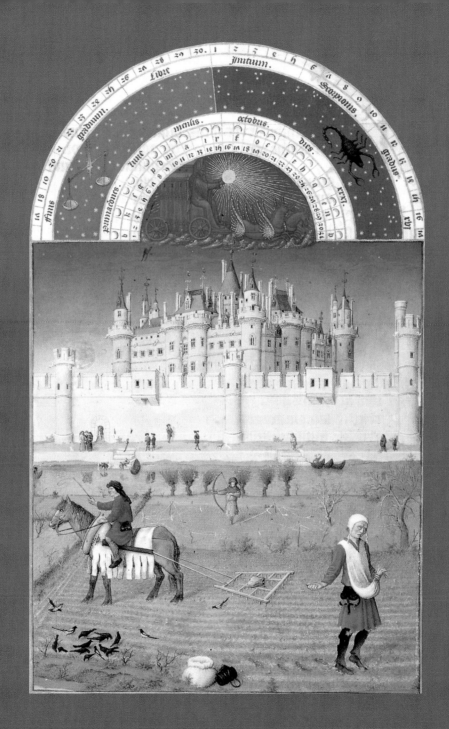

is not so much a manifestation of the medieval view of birds, beasts, and fish as it is of the absence of separation between church and science during the period. The placement of fact in the service of religion, combined with the acceptance of information without verification (including that found in the writings of the ancients), resulted in the amassing of a significant body of knowledge about animals only a small percentage of which was scientifically valid. This material provides superb insight into the era's view of the animal kingdom, and in a deeper sense into the way in which medieval men and women acquired and disseminated knowledge.

Detail of 124 **The Unicorn Crosses the Stream and Tries to Escape. Franco-Flemish, Brussels (?), c. 1500. Tapestry. Cloisters Collection, The Metropolitan Museum of Art, New York.**

SYMBOLISM

The Meaning of Animals
in Medieval Art

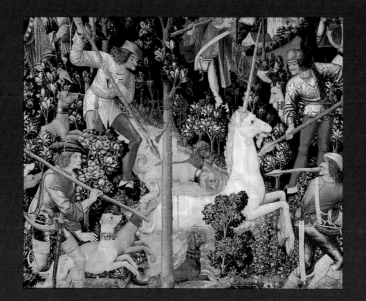

n his famous painting *The Garden of Earthly Delights*, the Flemish artist Hieronymus Bosch painted a fat pig, dressed as a nun, giving a naked little man a crushing embrace, which he resists (figure 90). As the devil stands near providing the inkwell, the mother superior pig attempts to force the dying man to sign a document, an encounter that alludes to the practice of wills being made under pressure in favor of monasteries. Bosch, painting in the early sixteenth century, has supplied sufficient information to make the meaning of his porcine predator clear.

Although Bosch was rarely as straightforward as here, the relative clarity of this example is not characteristic of earlier animal imagery. The medieval mind seems to have been attracted to complexity and ambiguity, which has led to great debate over the meaning of animals in medieval art. The strictest proponents of symbolic interpretation argue that every animal (and even every part thereof) is freighted with meaning, while others claim that they are primarily ornamental and were employed for their own intrinsically decorative appeal. But perhaps an animal may be simultaneously symbolic *and* decorative. And might not an animal be symbolic in some instances and not in others? [57]

The situation is complicated by the way in which medieval artists worked. In an era when signatures were rare and tradition was more valued than personal innovation, the image created by one artist served as the model for another without connotation of forgery or plagiarism. The medieval doctrine of *imitatio* makes it justifiable to suspect that an artist might copy a motif without a full understanding of its original

104

90 **G**arden of Earthly Delights, *detail of right wing of triptych.* **Hieronymus Bosch. Flemish, c. 1505–10. Prado Museum, Madrid.**

meaning. If an animal were copied from an Eastern, ancient pagan, or otherwise non-Christian source, would it necessarily have been given religious symbolism when reused in a medieval Christian environment?

Debate over the meaning and appropriateness of the animals in medieval art is not a recent development. Rather, strongly conflicting views were expressed during the Middle Ages. Saint Bernard of Clairvaux (1090–1153)—founder of the abbey of Clairvaux, leader of the Cistercian Order, and molder of twelfth-century religious thought—was far from favorable in his reaction to the use of animal imagery. A

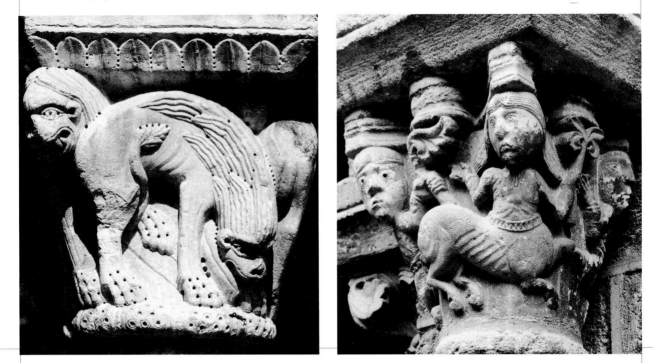

portion of a letter Bernard wrote in 1125 to William, abbot of Saint-Thierry, records his pronounced reference for the unadorned:

> In the cloisters, before the eyes of the brothers while they read—what is that ridiculous monstrosity doing, an amazing kind of deformed beauty and yet a beautiful deformity? What are the filthy apes doing there? The fierce lions? The monstrous centaurs? The creature part man and part beast? The striped tigers? The fighting soldiers? The hunters blowing their horns? You see many bodies under one head, and conversely many heads on one body. On one side the tail of a serpent is seen on a quadruped, on the other side the head of a quadruped is on the body of a fish. Over there an animal has a horse for the front half and a goat for the back; here a creature which is horned in front is equine behind. In short, everywhere so plentiful and astonishing a variety of contradictory forms is seen that one would rather read in the marble than in books, and spend the whole day wondering at every single one of them than in meditating on the law of God. Good God! If one is not ashamed of the absurdity, why is one not at least troubled at the expense?[58]

Bernard's eloquent objection provides an inventory of some of the favorite motifs of his era (see figures 91–94). Had animal imagery been rarer in the Middle Ages, perhaps Bernard would have been less inclined to complain about it, or perhaps he would not have been bothered if the creatures were favored only among lay people. But to his horror they were popular even on the capitals in the monastery cloister.

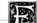

91 **Fierce Lions. Marble capital from cloister of Saint-Michel-de-Cuxa, France, mid-twelfth century.**

92 **Monstrous Centaurs. Capital from cloister of Notre-Dame, Le Puy, France, twelfth century.**

Clearly, Bernard did not consider animals to be useful as religious symbols. Instead, he complained about the "ridiculous monstrosities" as diversions from serious concerns. Furthermore, he was opposed to the cost—these capitals, he said, were a misuse of church capital.[59]

A very different view of the role of animal imagery was noted in the bestiaries. The physical and behavioral characteristics of almost every animal described in the bestiaries are used allegorically as the basis of anecdotes and stories, usually of a religious nature, which are meant to edify the reader. The great importance attached to allegorical interpretation is made clear by giving the moral lesson provided by each beast as much, if not more, emphasis, than the "scientific" descriptions of the creatures. The bestiaries were particularly popular in Bernard's century and their

93 **M**any Bodies under One Head.
Relief from cloister of Notre-Dame,
Le Puy, France, twelfth century.

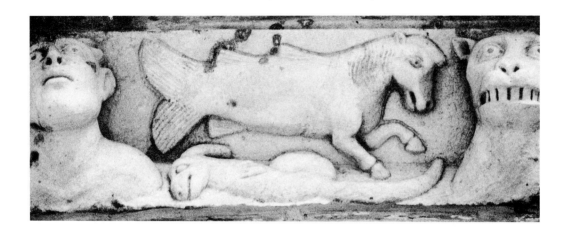

influence, like that of Bernard's words, was widespread. Although most people of the Middle Ages were illiterate, they had heard the symbolic interpretations of the bestiary creatures over and over again in church sermons.

About one hundred years after Bernard expressed his disapproval, a very different opinion on the use of animal imagery in religious environments was expressed by a Spanish author, Lucas, probably writing around 1230, nine years before becoming bishop of Tuy. "Certain images are painted or carved in the church of Christ for the defense of the faithful, for doctrine, for imitation, and for adornment," he wrote. "Some are for doctrine, imitation and likewise for adornment, and some are for adornment only.... There are in the church painted forms of animals, birds and serpents, and other things, which are for adornment and beauty only."[60] Lucas did not say that

94 **H**ead of a Quadruped on the Body of a Fish. *Relief from cloister of Notre-Dame, Le Puy, France, twelfth century.*

all creatures are obligated to convey doctrine but that some provide acceptable ornament for the church.

Lucas of Tuy explained that Solomon "enriched his temple with a wonderful beauty of gems, gold and silver, and decorated it with images of varied sculpture, so that it would make the name of God famous everywhere, and draw the nations of divers people to itself." Lucas cited the rich decoration of the temple of Solomon as a precedent justifying the churches of Lucas's time. And he pointed out that this beauty served a practical role in attracting the populace.[61]

Bernard of Clairvaux and Lucas of Tuy agreed that not all images of animals are meant to be symbolic. But Bernard objected strongly to animal imagery as an absurd-

ity that might distract from meditations on God, whereas Lucas found animals, birds, and serpents acceptable as ornament and useful in drawing people to the church. Although Bernard complained about the expense involved in decoration, Lucas cited historical precedent to argue that the church should be visually enriched.

While Bernard and Lucas appear to have held opposed views on the value of animal imagery, under certain conditions their beliefs might not have been so distant.

95 **inners in the Mouth of Hell.**
Tympanum of the Last Judgment,
west facade of Saint-Etienne,
Bourges, France, c. 1280.

Indeed sometimes the meaning of an animal is so clearly didactic that even Bernard might have found it useful rather than diversionary.

In some cases the connotation of a creature is explained by a literary source. For example, the sinners cooking in the cauldron in the *Mouth of Hell* carved at Bourges Cathedral (figure 95) have frogs emerging from their mouths, the meaning of which is made clear in Revelation (16:13–14). The text on folio 33 verso of the *Cloisters Apocalypse* (figure 96) translates: "And I saw issuing from the mouth of the dragon, and from the mouth of the beast, and from the mouth of the false prophet, three unclean spirits like frogs. For they are spirits of demons working signs." Based on this biblical description, the frog regularly appears in medieval art in association with the devil, the repulsive qualities of sin, and heresy.

The meaning of an animal may also be made clear by the way in which it is used. For example, the champlevé enamel dove in figure 97 functioned in the church ritual of the sacrament of the Eucharist or Holy Communion—the consecration of bread and wine as the body and blood of Christ. The dove hung over the altar and contained the Host (the bread was inserted through a hinged opening on the back). Some of these enameled doves were even made to be raised and lowered by a chain that causes the wings to flap. This dove is a clear symbol of the Holy Ghost—in John's words, "I saw the Spirit descending from heaven like a dove" (1:32).

Only rarely is the meaning of a specific creature based upon something other than its actual qualities or those attributed to it, as in the bestiaries. Perhaps the best example of this is the fish, the oldest Christian symbol for Christ. The fish was used

by the early Christians as a means of identifying themselves intended to be unintelligible to the uninitiated, including their persecutors. The fish was selected because the initial letters of the Greek words for *Jesus Christ of God the Son Saviour* spell *ichthus*—fish—thus its choice as a symbol for Christ was based upon an acrostic rather than an association of the qualities of fish with Christ.

Although in these cases the symbolism of the creature is readily explained, the meaning of many animals in medieval art is far more complex. There may be multiple meanings, and these may be highly contradictory. Yet what seems like irreconcilable conflict today was not only acceptable to the people of the Middle Ages but intentionally cultivated. Not only were layered meanings common, there was also a deliberate attraction to the kind of iconographic intricacies that encouraged the creation of contradictory connotations. As a method of interpreting the natural and religious worlds, symbolism provided the medieval artist with a way to deal with the many things that could not be explained in more concrete ways—or did not need to be—for in the Middle Ages the visible and the invisible were closely related.

This sort of dichotomy can be demonstrated by the lion, the animal portrayed most often by the medieval artist. Most of the roles played by the lion cast him in a favorable light. The lion frequently functions as a guardian, a job for which he is well suited due to the medieval belief, recorded in the bestiaries, that he never closes his eyes, even while sleeping. Guard lions appear in different forms, in a variety of materials, and in many geographic areas: the lion seen in figure 77 was originally one of a pair flanking the entryway to a church in northern Italy; the fresco lion from

96 **he Unclean Spirits** *from the* **Cloisters Apocalypse, fol. 33v. Normandy,** **c. 1300–1325. Cloisters Collection,** **The Metropolitan Museum of Art, New York.**

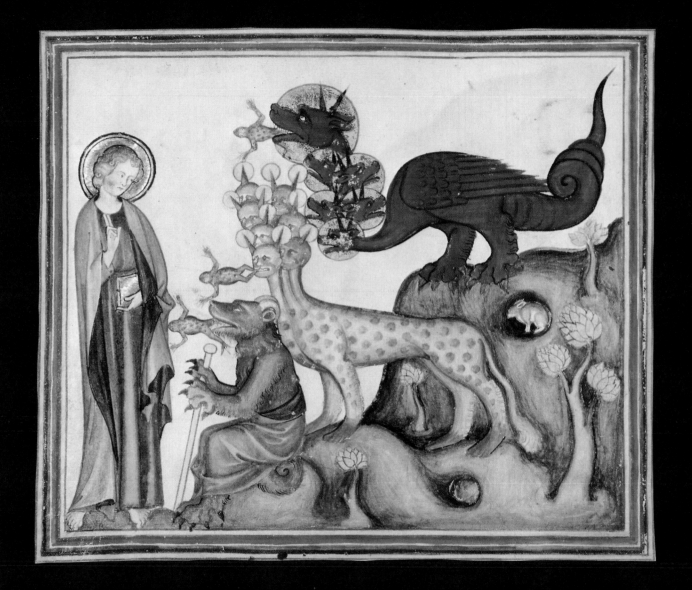

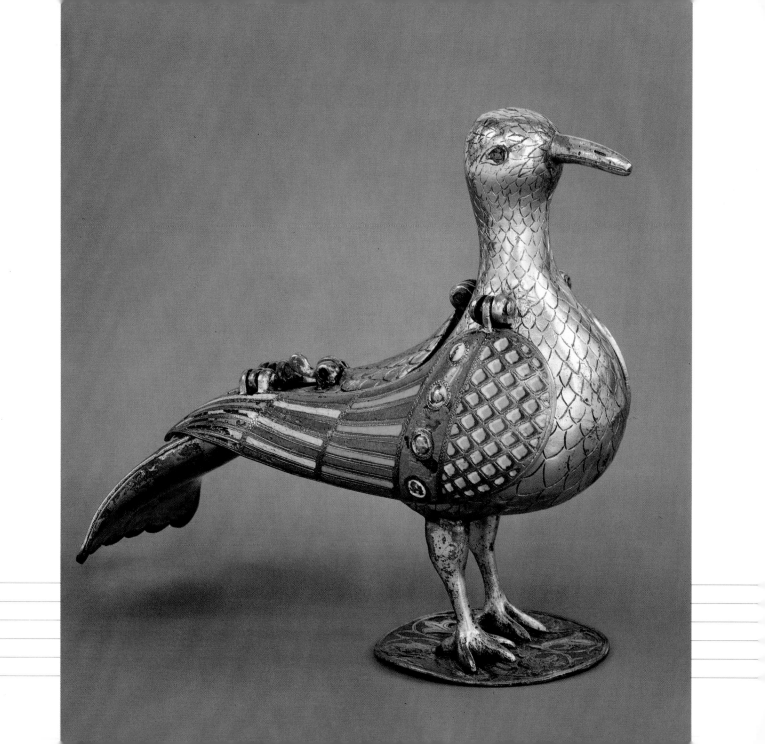

Spain shown in figure 78, also one of a pair, bordered the entryway to a chapter house; in France three lions and three lionesses standing on each others' hips and snouts dominate the narthex trumeau of Saint-Pierre in Moissac (figure 101).[62]

How effective the lion might be in protecting the faithful is demonstrated by one seen devouring a sinner at Oloron-Sainte-Marie (figure 102). At Sainte-Marie in

97 **E**ucharistic Dove. *French, Limoges, thirteenth century. Copper, gilt, and champlevé enamel.*
Cloisters Collection, The Metropolitan Museum of Art, New York.
■ *Doves such as this were a specialty of the Limoges enamel studios in the twelfth
and thirteenth centuries.*

98 *Lions. Capital from the porch of Saint-Benoit-sur-Loire, France, eleventh century.*

Souillac lions viciously attack a goat (figure 149), and at Mainz Cathedral two are about to pounce on another goat (figure 104), symbol of the sinner.

In addition to guarding the church, the medieval lion also guarded individual people, especially in death. The funeral effigy of Jean d'Alluye (d. 1248) includes a lion at his feet (figure 107). Because of the bestiary tale that the father lion revives his cubs three days after they are stillborn, the lion is additionally associated with the Resurrection and hope for the afterlife, and his presence also connects Jean d'Alluye with the lion's nobility, courage, and other desirable qualities.

116

 99 *illar Base with Animals. Narthex, Cathedral, Santiago de Compostela, Spain, twelfth century.*

■ *Upon entering the celebrated cathedral of Santiago de Compostela, the pilgrim is greeted by this group of crouching creatures.*

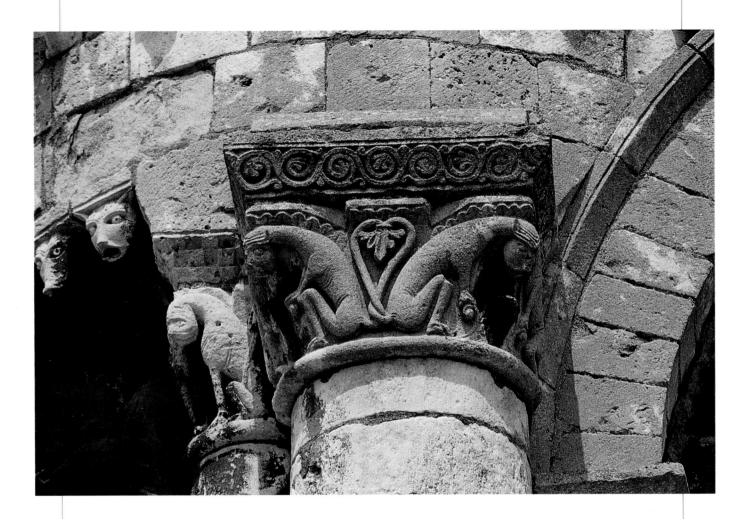

 100 **L**ions with Twined Tails. *Capital from Notre-Dame-la-Grande, Poitiers, France, twelfth century.* ■ *This mirror-image pair creates hearts and flowers with their tails.*

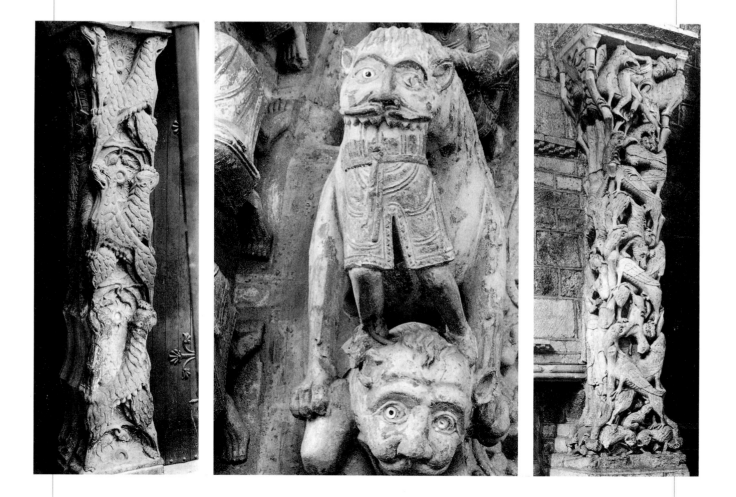

101 **T**rumeau with Lions. *South portal of narthex at Saint-Pierre, Moissac, France, c. 1100–30.*

102 **Lion Devouring Sinner.** *Former Cathedral of Sainte-Marie, Oloron-Sainte-Marie, France, twelfth century.*

103 **Griffins Attacking.** *Trumeau, now on interior of facade. Abbey of Sainte-Marie, Souillac, France, c. 1115-30.*

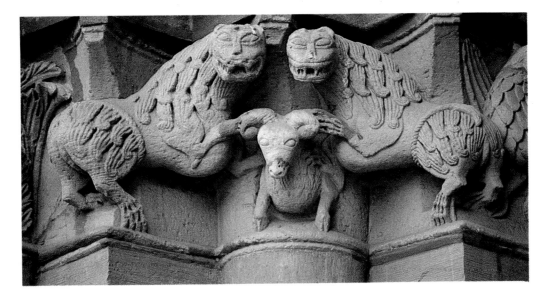

Because of these qualities the lion appears frequently in medieval heraldry, a fine example of which is provided by the enamel tomb plaque of Geoffrey Plantagenet (d. 1151), which shows the count of Anjou carrying a shield with a golden lion (figure 108).[63] The military aristocracy of the Middle Ages admired the lion's regal nature, strength, and attraction to combat—consider Richard I of England (ruled 1189–99), known as Richard the Lion Heart. Standing upright on one or both back legs, the fierce combative pose of the lion rampant was favored over the lion passant, or walking.

104 **Lions Attacking Goat. Capital**
from east end portal, Cathedral, Mainz,
Germany, c. 1090–1100.

105 **ion Trampling Vipers. North German, possibly Lübeck, c. 1200. Bronze and gilt aquamanile.**

 The Metropolitan Museum of Art, New York; Robert Lehman Collection.

106 **Lion-Dragon Chasing Goat. Capital from abbey church, Maria Laach, Germany, twelfth century.**

Overleaf 107 **Tomb Effigy of Jean d'Alluye. French, c. 1248. Limestone sarcophagus lid.**

 Cloisters Collection, The Metropolitan Museum of Art, New York.

The lion also appears in medieval art as the companion of Saint Jerome—not as a symbol of military power but as a symbol of the power of kindness. The story of Jerome and the lion recalls that of the ancient slave Androcles and the lion. Androcles is condemned to be torn apart by a lion in the arena, but the lion recognizes him as the person who many years earlier had removed a thorn from his paw, and greets his would-be victim by affectionately licking his hands and feet. The audience is so impressed by this display of feline affection that Androcles is freed, and the lion departs with him to become his constant companion about town.[64]

In the medieval version a comparable encounter occurs when a lion limps into Saint Jerome's monastery at Jerusalem. All the monks flee in fear except Jerome. But the lion has come neither to prey nor to pray; neither his stomach nor his soul need solace, rather, it is his sole that suffers. So Jerome removes a

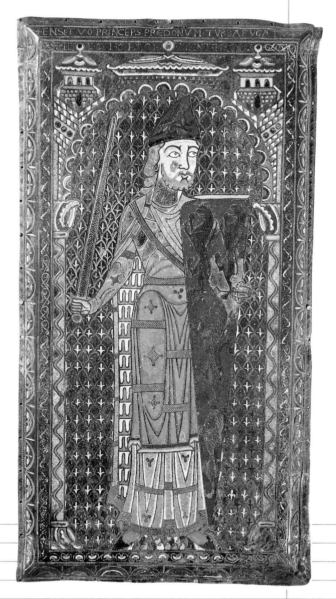

 108 *Funeral Effigy of Geoffrey Plantagenet. French, c. 1151. Champlevé enamel on gilded copper plaque. Musée Tessé, Le Mans, France.*

thorn from the lion's paw (figure 109), after which the lion becomes Jerome's companion, living and working in the monastery. In the Saint Jerome story the names and setting have been changed to accommodate a different audience, but the basic story and the message it contains have been perpetuated: a wild beast is tamed by kindness, which he repays in kind.

Other admirable qualities of the lion are demonstrated by a second part of the Saint Jerome story: like everyone else in the monastery, the lion must work for his food and is given the job of guarding the monastery's donkey when he transports wood. But when the lion is not alert the donkey is stolen and sold to merchants. The lion, accused of eating the donkey, is given the donkey's job as punishment and he humbly does this work—until he sees the donkey in the merchants' caravan and leads the whole caravan to the monastery in proof of his innocence (figure 110).

Although the lion is usually shown in a favorable light, he is also used to symbolize evil,[65] particularly in the Psalms, where he represents the devil: "They gaped upon me with their mouths, as a ravening and a roaring lion" (Psalm 22:13); "Save me from the lion's mouth" (Psalm 22:21); "Lest he tear my soul like a lion, rending it in pieces while there is none to deliver" (Psalm 7:2). Peter in Epistle 5:8 also writes: "Be sober, be vigilant; because your adversary the devil, as a roaring lion, walketh about, seeking whom he may devour."

The celebrated sculpture of Christ known as the *Beau Dieu*, on the trumeau of the west facade of Amiens Cathedral, includes four animals beneath Christ's feet (figure 148), an arrangement illustrating Psalm 91:13: "Thou shalt walk upon the adder and

109 ***tory of Saint Jerome and the Lion from the Belles Heures de Jean, Duc de Berry, fol. 186v. Limbourg brothers. French, c. 1410-16. Cloisters Collection, The Metropolitan Museum of Art, New York.***

1 2 4

Quadā die leo claudicās monasteriū igreslus
est ieronimi aut cum ceti sugient qi hospita obui

Alia aut̃ uice cuſtodiẽs aſinũ leo ſompno gr̃at̃
dormiuit aſinũ poit exſpergeſ fr̃ns uigileſ ſociũ
nõ repeut hinc in de gŕ aſinũ a longe uenientẽ
uidet eñ camelľ ouor ad mõſteriũ fr̃ cõ opt

the basilisk, the young lion and the dragon shalt thou trample under feet." Saint Augustine interprets these four animals to be four aspects of the devil, the adder (or asp) representing sin and the sinner; the basilisk representing death, the devil, or the Antichrist; the lion representing the Antichrist; and the dragon representing the devil. Trampling the four, Christ is symbolically shown triumphant over his enemies.[66]

The lion also appears as an instrument of evil in the Old Testament story of Daniel thrown into the lions' den for praying to his God and refusing to worship King Darius (figure 111). Daniel is rewarded for his faith when God closes the lions' mouths (Daniel 6:23). In medieval art Daniel is never shown fighting the lions and in some cases the lions even pay homage to Daniel.

An Old Testament figure who *does* fight a lion is Samson (figure 112), whose successful combat demonstrates his great strength.

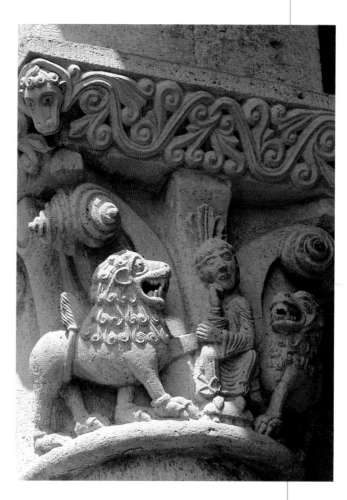

 110 tory of Saint Jerome and the Lion *from the Belles Heures de Jean, Duc de Berry, fol. 187r. Limbourg brothers. French, c. 1410-16. Cloisters Collection, The Metropolitan Museum of Art, New York.*

111 Daniel in the Lions' Den. *Capital from former abbey of Saint-Gérard, La Sauve-Majeure, France, twelfth century.* ■ *Daniel has nothing to fear since the bestiary assures us that lions with curly manes are peaceful.*

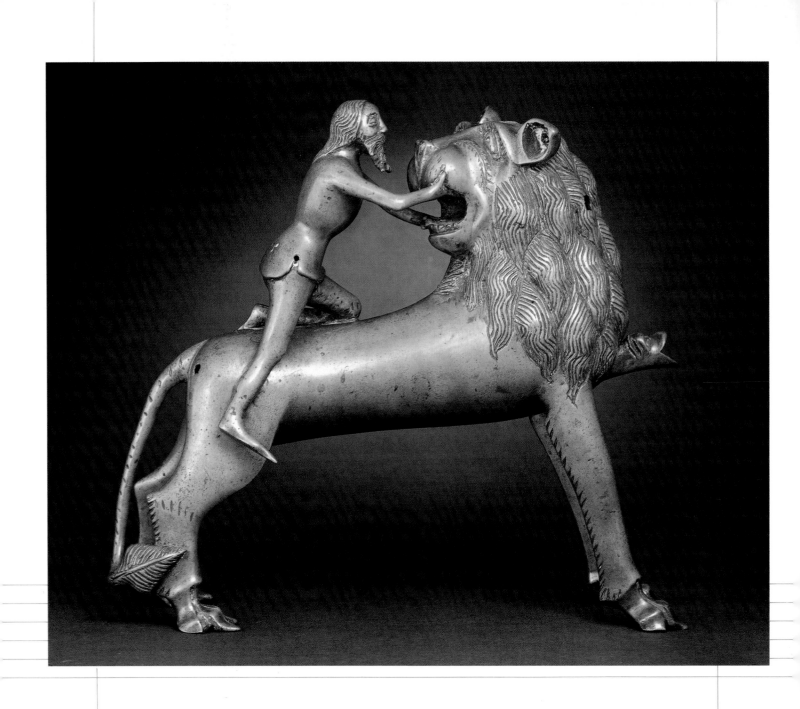

There is another version of the Samson story, however, in which the lion represents Christ destroyed by mankind. In this tale, several days after killing the lion Samson goes to the corpse and finds a swarm of bees and honey (Judges 14:8). It was well known that flies come to the wounds of other animals, but for the king of the beasts a more prestigious insect is required. The bestiaries too confirm that bees make honey in the wounds of injured lions.

It is apparent that the lion's multiple roles in the art of the Middle Ages often blatantly conflicted with one another. Viewed favorably (*in bono*), the lion is king of the beasts, merciful and just, a vigilant guardian, a symbol of Christ and the Resurrection. Viewed unfavorably (*in malo*), the lion is the Antichrist, the devil, and evil in general.

Like the lion, the griffin is used in medieval art to suggest both positive and negative qualities. But in the case of the griffin, an animal equipped with feathers and fur, this duality is the result of the composite nature of his anatomy. The variety of physical characteristics given to the medieval griffin, the extensive geographic area over which he appears, and the range of materials from which he could be fabricated are indicated by the French voussoir in figure 9, the English bestiary illumination in figure 113, and the German aquamanile in figure 114. This diversity is probably explained by the griffin's complex lineage, which involves several kinds of ancient creatures with the body of a lion and the wings and head of a bird.[67]

When viewed favorably the griffin combines the strength and nobility of the lion, king of the beasts, with the ability to soar and the excellent vision of the eagle, king

112 **amson and the Lion. Bronze aquamanile.**
North German, late fourteenth century.
The Metropolitan Museum of Art, New York;
Robert Lehman Collection.

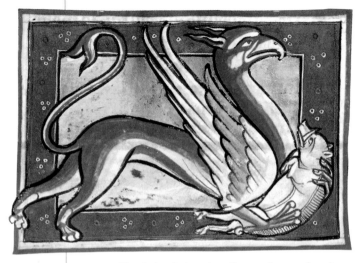

of the sky, to produce an ideal composite creature. As such the griffin becomes a symbol of Christ, a guardian, and, in medieval heraldry, an emblem of valor.[68]

But viewed negatively the griffin represents the Antichrist, who oppresses and persecutes Christians with the fierceness of the lion and who preys on his victims like an eagle.[69] The griffin's wild destructive power is coupled with a desire to dismember men—although, curiously, his special hostility is reserved for horses. In the *Travels* of Sir John Mandeville, a chronicle of a trip to the Holy Land and Near East that the author claims to have begun in 1322,[70] the griffin is described as bigger than eight lions and having greater force than a hundred eagles.

The griffin's viciousness is demonstrated on a complex trumeau at Sainte-Marie in Souillac (figure 103). Three griffins, aided by other beasts, scratch and bite their prey with claws, beaks, and teeth. From the top down, their victims are a naked and defenseless man, a peaceful dove, a faithful dog, and a gentle gazelle. As on the trumeau at Moissac (figure 101), the Souillac animals are arranged in three crossed pairs, but on the Souillac trumeau the animals are menacing monsters that dramatically demonstrate the dangers of sin. The sculptor has provided the worshipper with

113 *riffin from the Worksop Bestiary, fol. 36v. English, twelfth century.*
Morgan Library, New York, MS M.81.

114 *Griffin. Brass aquamanile. German, Nüremburg, c. 1400.*
The Metropolitan Museum of Art, New York;
Robert Lehman Collection.

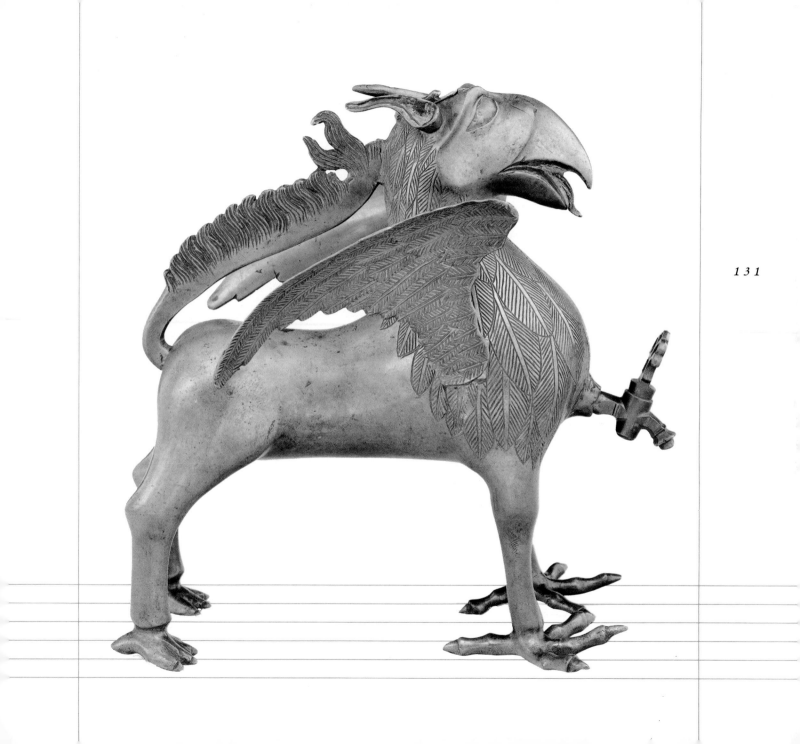

131

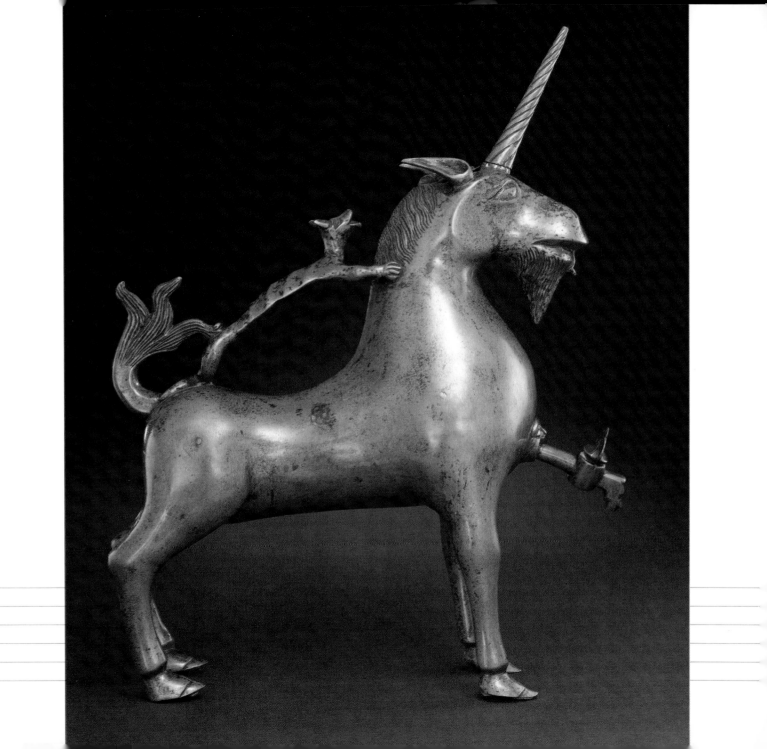

an image of Hell intended to discourage even the most determined sinner.

Another imaginary animal in medieval art that also has more than one meaning is the unicorn. But rather than being both good and bad like the griffin, the unicorn's double nature combines the religious and the secular. The unicorn is featured in two famous tapestry series, one at the Cloisters in New York and the other, known as *The Lady and the Unicorn,* exhibited at the Musée de Cluny in Paris. Five of the six Cluny tapestries represent the senses, a subject that recalls the words of Master Richard de Fournival in his *Bestiary of Love.* Breaking with the bestiary tradition of interpreting the animals according to Christian religious symbolism, Richard secularizes the bestiary by substituting amorous analogies. "I was captured . . . by smell, like the Unicorn which falls asleep at the sweet smell of maidenhood," he writes. "It falls asleep in her lap…when it is asleep the hunters…kill it.…I say that I was captured by these three senses: hearing, sight, and smell. And if I had been completely captured by the other two senses—taste by kissing and touch by embracing—then I would truly have been put to sleep."[71]

The *Sense of Hearing* (figure 116) is represented by the lady playing an organ with a golden unicorn and lion as finials. The "live" unicorn and lion hold banners and serve aesthetically to bracket the composition. Curiously, the *Sense of Sight* (figure 117) is demonstrated not by the lady but by the unicorn, who looks in a mirror. Although the lady appears disinterested, the unicorn is evidently pleased by what he sees. In the tapestry for the *Sense of Smell* (figure 118), a lady weaves a garland of flowers, assisted by a girl who brings white and pink carnations[72] while the unicorn

133

115 **nicorn. Brass aquamanile.**
German, Saxony, c. 1400. The
Metropolitan Museum of Art, New York;
Gift of Irwin Untermeyer.

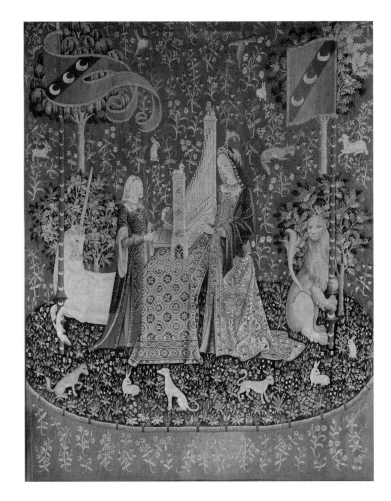

 116 ense of Hearing.

117 **Sense of Sight. Both, Franco-Flemish, Brussels (?),**

c. 1480-1500. Tapestry. Musée de Cluny, Paris.

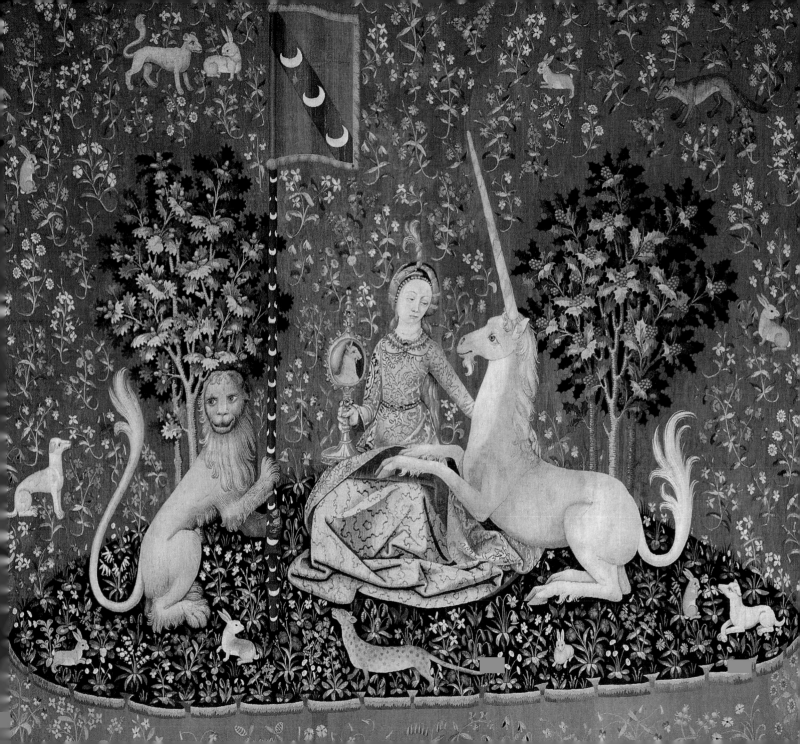

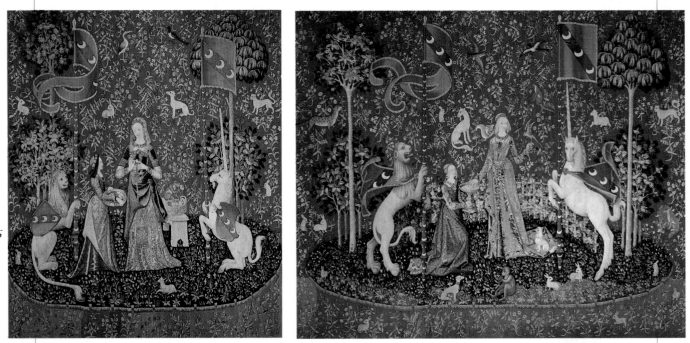

looks on almost smugly. The *Sense of Taste* tapestry (figure 119) portrays the lady taking food from a bowl while a parakeet on her left hand and a monkey also eat. The lion and unicorn actively rear up, proudly displaying the crest of the Le Viste family, a member of which commissioned the tapestry cycle.[73] For the *Sense of Touch* (figure 120), the lady touches the unicorn's horn; his face, like that of the lion, is expressive and notably human. Indeed, throughout these tapestries the animals tend to be more expressive than the lady or the girl.[74]

118 **Sense of Smell.**

119 **Sense of Taste.**

120 **Sense of Touch. All three, Franco-Flemish, Brussels (?),**
 c. 1480-1500. Tapestry. Musée de Cluny, Paris.

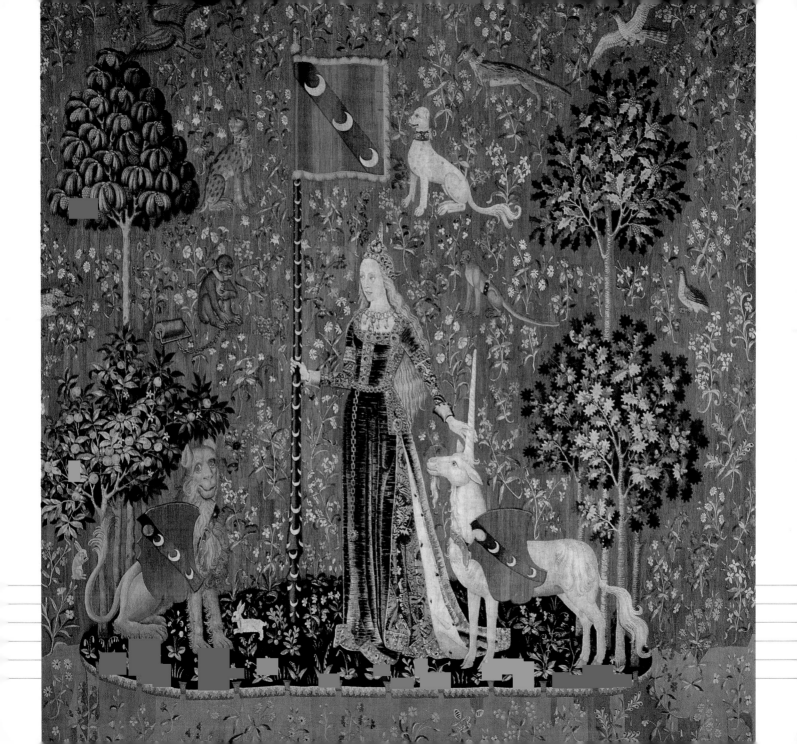

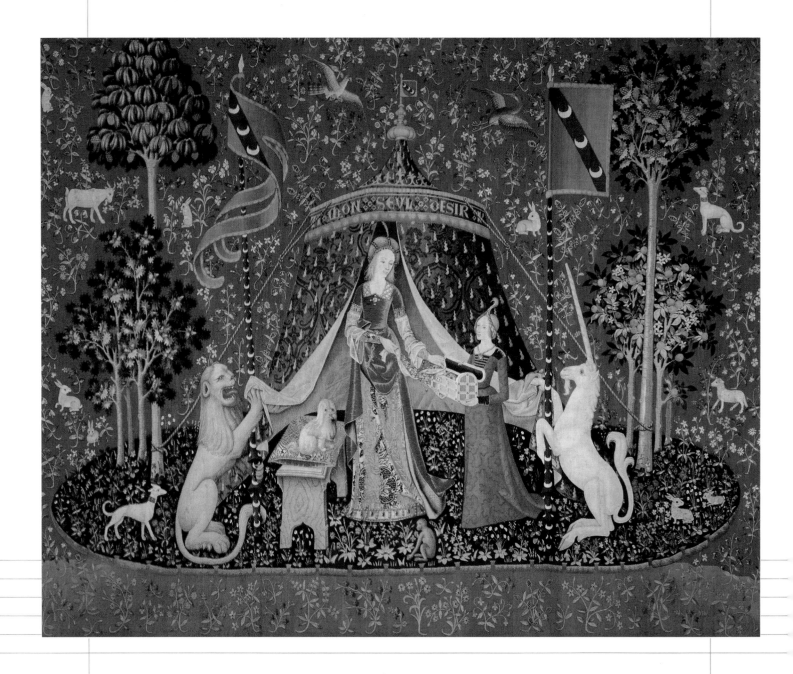

In the sixth tapestry the lady stands before a tent on which the phrase *A Mon Seul Désir* (*To the Only One I Love*) appears (figure 121), while the unicorn and the lion open the flaps to the tent. The meaning of this tapestry depends upon the meaning of the lady's gesture. Does she put jewels into the coffer held by the girl or take them out? The same gesture also appears in another set of tapestries entitled *The Senses,* which consists of five scenes representing the senses plus another called *Free Choice* in which a woman renounces her jewels, emblematic of the sensuous life. If the lady in the Cluny tapestry is also putting the jewels she wore in the other tapestries into the box, her gesture would suggest renunciation. The subject may have to do with the ancient idea of free will, which Socrates and Plato suggest would lead us to behave as we should, if only our senses or passions did not lead us astray.

Alternatively, it has been proposed that the tapestries were made as a wedding gift for the lady depicted. According to this interpretation, in the sixth tapestry the lady is shown taking her marriage belt on her veil of virginity. The symbolism of those animals given special prominence in the tapestry cycle supports the marriage theory,[75] for the unicorn represents virginity, chastity, and courtly love. Although the unicorn of the bestiary is a symbol of Christ, the beast is also a symbol of virginity because, like Christ, he goes to a virgin. The cult of the Virgin Mary, very strong in the late Middle Ages, included aspects of chivalrous love that permitted a romantic and even erotic interpretation of the unicorn. When shown in the context of a marriage tapestry, the lion refers to faithfulness in love and marriage (as Konrad von Megenburg's

121 **Mon Seul Désir. Franco-Flemish, Brussels (?), c. 1480-1500. Tapestry. Musée de Cluny, Paris.**

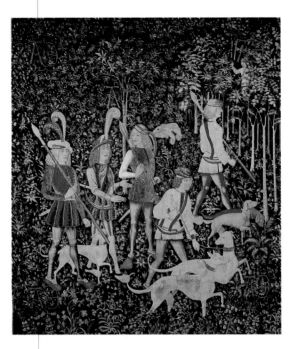

fourteenth-century book on nature says, the lion "has nothing of infidelity about him"). Because of their ability to multiply rapidly, rabbits are a common symbol of fertility, and significantly, they appear with greater frequency than any other animal in the tapestries. A high infant mortality rate made procreation a major marital concern in the Middle Ages, particularly among the nobility anxious for offspring to carry on the family title and fortune. Finally, the dog accompanying the lady, as noted above, was a standard symbol for fidelity as well as domesticity.[76]

In an equally splendid set of tapestries known as *The Hunt of the Unicorn* at the Cloisters in New York, the unicorn plays a different role—or roles—in a hunting story patterned after the popular upper-class pastime of the stag hunt.

In the *Start of the Hunt* (figure 122) several men, with the aid of dogs, seek the location of the unicorn. The greyhounds hunt by sight and the running hounds hunt by scent—one sniffs the ground with his suitably large nose. In the upper right of the tapestry a man in a tree signals to indicate that he has spotted the unicorn.

122 **tart of the Hunt.**

123 **The Unicorn Purifies the Water at the Fountain.**

Both, Franco-Flemish, Brussels (?), c. 1500. Tapestry. Cloisters Collection,

The Metropolitan Museum of Art, New York.

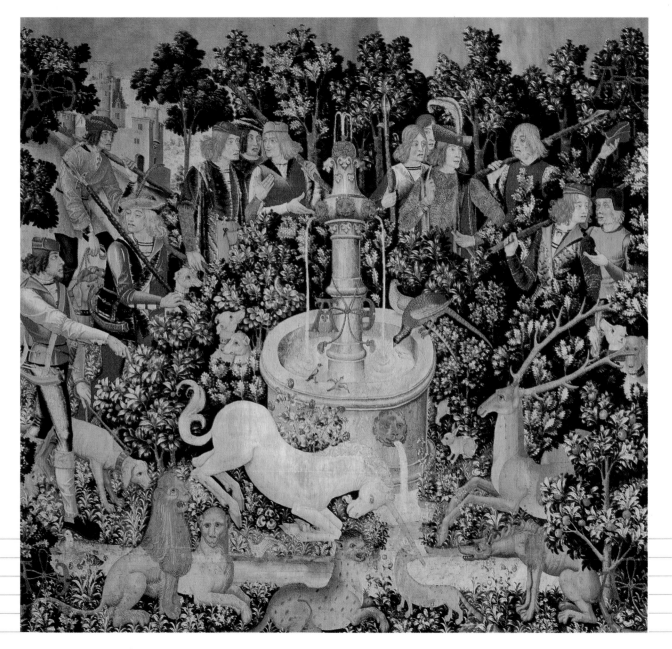

The second tapestry depicts *The Unicorn Purifying the Water at the Fountain* (figure 123). Here, the unicorn demonstrates the magic power of his horn by dipping it into poisoned water, thereby removing the poison or rendering it harmless.[77] In some literary descriptions of this scene the unicorn makes the sign of the cross with his horn to rid the water of the poison, a gesture that certainly suggests that the unicorn is a symbol of Christ. According to the tale, the water was poisoned by a serpent, the poisoned waters symbolizing the sins of the world and the serpent Satan. The twelve hunters are then interpreted as the twelve apostles and the one who points out the location of the unicorn is Judas.

Religious and secular symbolism can easily overlap in medieval iconography, however. According to secular interpretation, the unicorn is the chivalrous lover and bridegroom (like the Cluny tapestries, those in the Cloisters may have been made as a wedding gift[78]). Among the many animals waiting to drink the water, those that appear in pairs reinforce the marriage tapestry theory. The lion and lioness, when shown together as here, symbolize fidelity in love, for the bestiary says that the lion, king that he is, disdains to have many wives. The rabbits represent fertility, and the goldfinches on the fountain have long carried the same connotation; indeed Pliny writes that the goldfinch, although tiny, produces a dozen offspring. The pheasants on the opposite side of the fountain warn against something to avoid in a marriage. They are said to be jealous even of their own reflection, which the male sees in the water.

Some of the animals that support a secular interpretation also reinforce a religious one. The lion can be a symbol of Christ, as can the goldfinch because the thorns and

124 **he Unicorn Crosses the Stream and Tries to Escape. Franco-Flemish, Brussels (?), c. 1500. Tapestry. Cloisters Collection, The Metropolitan Museum of Art, New York.**

thistles (or their seeds) that he eats are linked to Christ's crown of thorns.

With the exception of the unicorn, the many animals in this tapestry and the others in the series are all real, though not necessarily rendered realistically, and the beliefs associated with them were not required to have a basis in actual fact.[79]

The third tapestry shows *The Unicorn Crossing the Stream and Trying to Escape* (figure 124). The unicorn, like the stag in medieval stories of the hunt, cleverly goes into the stream to cool himself, to hide his tracks, and to wash off his scent so that the dogs cannot follow him. The tapestry may also record an actual hunting technique

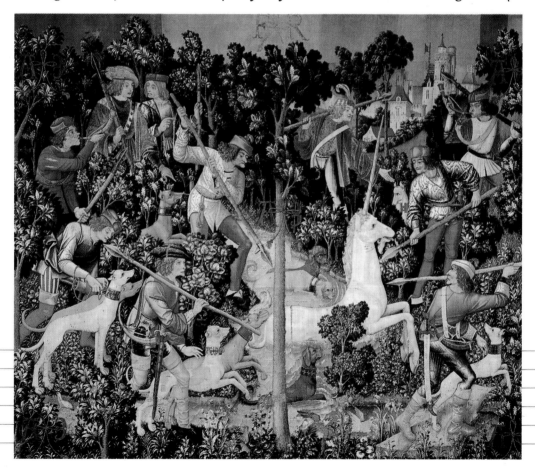

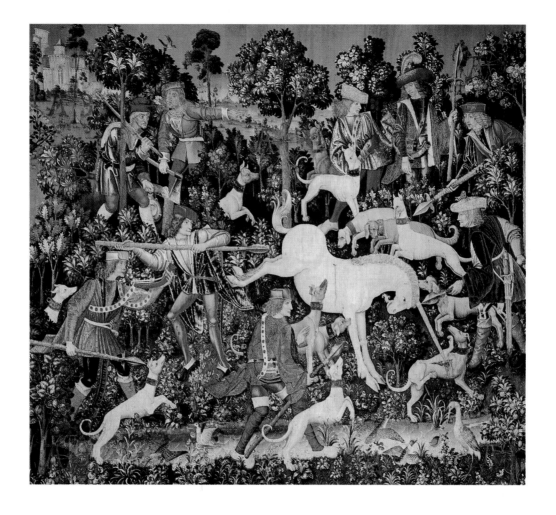

125 **T**he Unicorn Defending Himself.

Franco-Flemish, Brussels (?), c. 1500.

Tapestry. Cloisters Collection,

The Metropolitan Museum of Art,

New York.

in which the quarry is driven into a body of water so that the sudden change in temperature will shock the animal into immobility.[80] The unicorn responds by sticking out his tongue at his attackers but will demonstrate more effective defenses in the next tapestry.

The subject is *The Unicorn Defending Himself* as the hunters attack (figure 125). This image seems to illustrate Ctesias's description of the unicorn: "They fight with thrusts of horn; they kick, bite, and strike with wounding force both horses and hunters."[81] The hunter blowing his horn has been associated with the angel Gabriel of the Annunciation because the banner hanging from his spear says "Ave Regina C[oelorum]" ("Hail, Queen of the Heavens"), which was a popular hymn in the Middle Ages.

The fifth tapestry, *The Unicorn Deceived,* is now fragmentary (figure 126). As noted in the bestiaries and originally illustrated here, the unicorn can only be caught by a beautiful virgin. Some early writers discuss the unicorn's remarkable ability to recognize a virgin on sight.[82] The woman in the fragment is not the beautiful maiden, she is the accomplice in the unicorn's capture who signals to the hunter. Damage to the tapestry has left the deceitful virgin with only her fingertips and her brocade sleeve under the unicorn's chin.[83]

The sixth tapestry shows *The Unicorn Killed and Brought to the Castle* (figure 127). The murder of the unicorn is overtly brutal—encircled by hounds and hunters, bitten and speared, the unicorn is a helpless victim. The remainder of the tapestry depicts the dead unicorn placed across the back of a horse and delivered to the castle.

Already a man grasps the horn. The unicorn wears a necklace of thorns, presumably a reference to Christ's crown of thorns, particularly since the lady lifts her rosary at the approach of the dead animal.[84]

Fortunately for those who appreciate a happy ending, the last tapestry in the series shows the unicorn alive (figure 128). According to religious interpretation, the indestructible unicorn is the Christ of the Resurrection. But according to secular interpretation, the unicorn is the bridegroom who has endured great suffering to win his lady's favor. This technique of wooing works: the circular fence shows the unicorn

126 he Unicorn Deceived.

127 **The Unicorn Killed and Brought to the Castle.**

128 **The Unicorn in Captivity.** *All three, Franco-Flemish, Brussels (?), c. 1500.*

Tapestry. Cloisters Collection, The Metropolitan Museum of Art, New York.

surrounded by her love. Further, he wears the *chaine d'amour* ("chain of love"), often mentioned by medieval authors in allegories of love as an indication of a gentleman's total submission to the will of his lady.[85]

The red on the unicorn's white fur is not blood but juice from the pomegranates above,[86] the symbolism of which supports both the religious and the secular iconography of the unicorn. Interpreted religiously, the red juice represents life out of death and the Resurrection, and the many seeds symbolize the unity of the church and serve as an allegory of hope. Yet according to secular interpretation the seeds symbolize human fertility and the crownlike terminal represents royalty. Religious and secular symbolism are combined in one fruit (the pomegranate) as easily as in one animal (the unicorn).

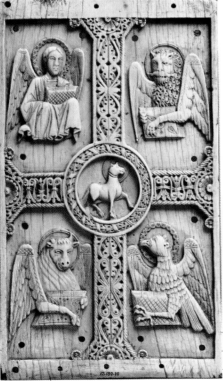

Unlike the unicorn's disparate meanings, an example of extremely consistent animal symbolism is provided by the so-called "four animals": the winged man, the winged lion, the winged ox, and the eagle used to represent the four Evangelists, Matthew, Mark, Luke, and John respectively. The "four animals" derive from Ezekiel's prophecy (I:5–II) and John's Revelation (4:6–8). In Ezekiel, four living creatures are described, each having four faces like those of a man, a lion, an ox, and an eagle; in John, each has only one of those heads. The association of these four animals with the four Evangelists

129 **A**nimal Symbols of the Four Evangelists and the Agnus Dei. *German or north Italian, probably ninth century. Ivory plaque. The Metropolitan Museum of Art, New York.* ■ *These anthropomorphic symbols receive great prominence—indeed here they are bigger than the symbol of Christ as the Lamb of God in the center.*

apparently begins in the late second century with Irenaeus (177–202), bishop of Lyon.

Victorinus of Pettau (d. 303), African Neoplatonic philosopher and bishop of Poetovio, identifies the four animals in John's vision with the four Evangelists by associating each animal with the opening lines of the Gospel of each Evangelist. Matthew is likened to the man because his Gospel begins with Christ's earthly ancestry and his human nature. Mark is associated with the lion because his Gospel begins with a voice crying in the wilderness, "vox clamantis in deserto," which is associated with the lion's roar: presumably the lion is also appropriate because his Gospel emphasizes the royal dignity of Christ and dwells on the Resurrection with which the lion is associ-

130 **Animal Symbols of the Four Evangelists. South German, thirteenth century. Embroidered cape. Musée Historique des Tissus, Lyon, France.**

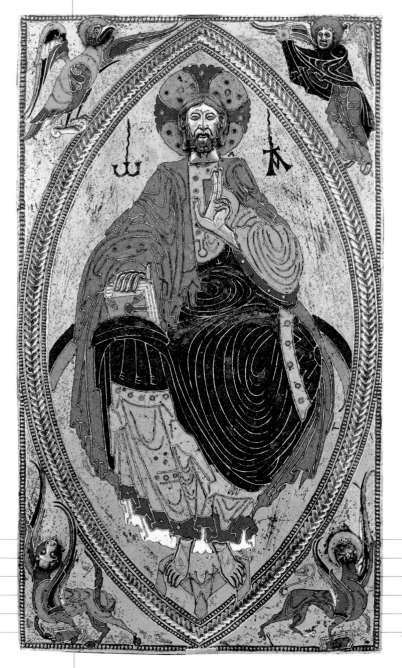

ated. Luke is represented by the ox, a sacrificial animal, because his Gospel begins with the sacrifice offered by Zacharias. And John is compared to the soaring eagle because his Gospel begins with the divine nature of Christ.

Saint Jerome (c. 342–420) associates each animal with an event in Christ's life. Thus, Christ is said to be man in his incarnation, ox in his death, lion in his resurrection, and eagle in his ascension.[87]

The symbolic character of the "four animals" is made easily recognizable by grouping them together as a unit and repeating the format in which they are depicted. The extraordinary nature of the "four animals" is made clear by equipping them with wings, haloes, and books or codices.

Images of the four animals of the Evangelists appear in all medieval

131 **C**hrist with the Animal Symbols *of the Four Evangelists. Limousine region of northern Spain, c. 1175-1200. Champlevé enamel on gilded copper plaque. Musée de Cluny, Paris.*

media and throughout the medieval Christian world. The four animals may be shown surrounding a lamb, as in the center of the Italian plaque in figure 129. The meaning of the lamb is made clear by comparing the same arrangement in figures 131 and 132, which shows a figure of Christ in the center. Similarly, the lamb appears on the central medallion of the famous English ivory *Bury Saint Edmunds Cross* (figure 133). Visual representations of Christ as a lamb go back to Early Christian times when it

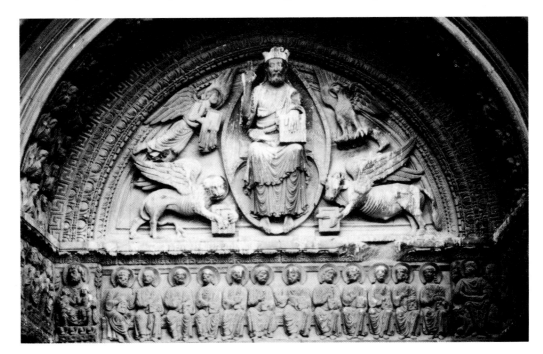

132 **Christ with the Animal Symbols of the Four Evangelists.**
Tympanum on west facade at Sainte-Trophime, Arles, France,
twelfth century. ■ This scheme was particularly popular above
the entryway to churches. It appears at Arles as well as at Bourges,
Carennac, Charlieu, Chartres, Moissac, and elsewhere.

was felt to be improper to represent Christ in human form. The association of Christ with a lamb derives from the traditional use of the lamb as a sacred sacrificial animal. In Revelation 5:12 and 14:1, John the Evangelist describes Christ as "the Lamb that was slain" and says "a Lamb stood on the mount Sion." John the Baptist (1:29) says: "Behold the Lamb of God, which taketh away the sin of the world." Medieval artists, fond of nuances, even used the pose of the lamb to indicate different aspects of Christ. Thus the standing lamb is the Church Triumphant; the lamb with blood spurting from his side into a chalice and holding a cross is the Agnus Dei (Lamb of God); and the lamb holding a banner decorated with a cross symbolizes the Resurrection and Christ the Redeemer.

 133 Bury Saint Edmunds Cross. Detail
of center medallion. English, mid-twelfth century.
Walrus ivory. Cloisters Collection,
The Metropolitan Museum of Art, New York.

From Early Christian times Christ is also depicted as a shepherd. In representations of *Christ the Good Shepherd* such as that at Saint-Julien in Brioude (figure 134), the lamb across Christ's shoulders represents either the sinner whom Christ saves (Luke 15:4–6) or the Christian flock that Christ protects and guides. Psalm 23:1 explains: "The lord is my shepherd." Similarly, Psalm 100:3 says: "we are his people, and the sheep of his pasture."[88]

The symbolism of the sheep is clear in the *Last Judgment* carved on the Early Christian sarcophagus in figure 135, in which Christ separates the saved (sheep) from the damned (goats). The idea of using goats to symbolize the damned sinners in portrayals of the Last Judgment comes from Matthew's statement (25:32, 33) that

153

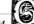 134 **Good Shepherd. Capital at Saint-Julien, Brioude, France, twelfth century.**

Christ will separate the believers from the nonbelievers "as a shepherd divideth his sheep from the goats." Further, Matthew says: "he shall set the sheep on his right hand, but the goats on the left." On this sarcophagus, Christ is shown gesturing in welcome to the sheep but rejecting the goats, which, significantly, are shown to be fewer in number.

Although in these examples the lamb/sheep serves as a symbol of Christ or of the saved who follow Christ, not every lamb or sheep in medieval art fits into one of these categories. Meaning is not fixed or constant; rather the connotation of the creature may vary according to the circumstances in which it is depicted. In some instances sheep—or other animals—may simply be deployed to clarify a narrative. For example, in portrayals of the *Annunciation of the Birth of Christ to the Shepherds*, as in the *Cloisters Apocalypse* (figure 136), sheep serve to identify the men as shepherds, like a prop in a theatrical stage setting. The assistance these sheep provide in telling the story must have been especially welcome at a time when literacy was not widespread.

135 ast Judgment. *Rome, late third–early fourth century.*
Marble sarcophagus lid. The Metropolitan Museum of Art, New York.

136 *Nativity and Annunciation to the Shepherds, from the*
Cloisters Apocalypse, fol. 1v. Normandy, c. 1300-1325. Cloisters Collection,
The Metropolitan Museum of Art, New York.

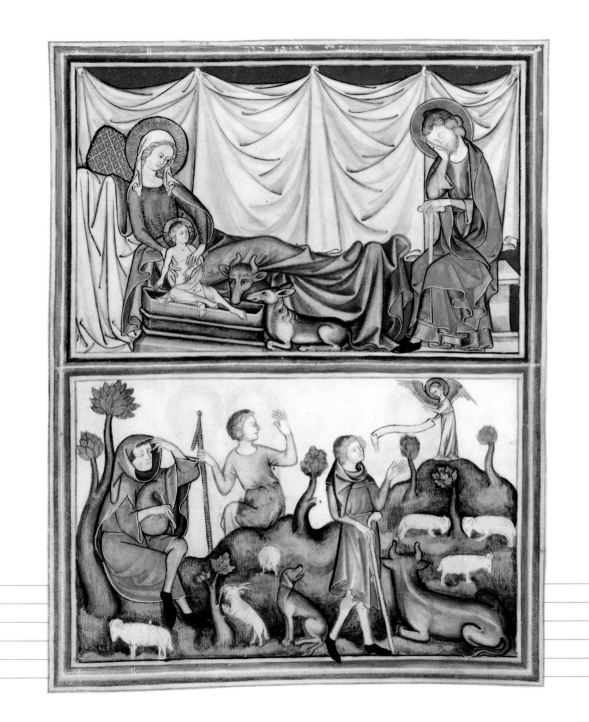

Sheep can appear even more simply as just sheep. This is demonstrated by the illumination for the month of July in the Limbourg brothers' *Très Riches Heures* (figure 137). In the illumination for each month in this manuscript, an activity considered especially characteristic of that month is realistically recorded. In the July image the shepherds shear the sheep.

Other familiar animals appear with special frequency in medieval art simply because they are standard elements in popular scenes. For example, depictions of the Nativity, central to the Christ story, routinely include an ox and an ass, as seen in the *Cloisters Apocalypse* (figure 136). This iconography derives from Isaiah (I:3), "The ox knoweth his owner, and the ass his master's crib." The implication is that even these humble low animals recognize Christ as the son of God.

Similarly, the donkey always appears as a means of transportation in scenes such as the Holy Family's *Flight into Egypt* (figure 138) and Christ's *Entry into Jerusalem* (figure 139). In the *Flight into Egypt*, Joseph, warned by an angel that Herod plans to massacre the infants, takes his family to Egypt for their protection (Matthew 2:13-14), and in the *Entry into Jerusalem* Christ enters the city riding on an ass and is greeted by a large crowd (Matthew 21:5-9).

Although the ox and the ass in Nativity scenes can be interpreted as symbolic, the ass/donkey in the *Flight into Egypt* or *Entry into Jerusalem* is

137 uly *from the* Très Riches Heures *de Jean, Duc de Berry, fol. 7v. Limbourg Brothers. French, early fifteenth century. Musée Condé, Chantilly, France.*

138 **Flight into Egypt. Relief from south portal of narthex at Saint-Pierre, Moissac, France, twelfth century.**

required by the narrative. The animal serves to convey Christ—not to convey subtle iconographic connotations. Once again, whether the animal should be interpreted symbolically or not is dependent upon the context in which that animal appears.

Some creatures seem to serve neither a symbolic nor a narrative purpose but, instead, were created primarily or even solely for their ornamental appeal. Although it would be possible to conjure up a symbolic connotation for every beast ever drawn, painted, carved, cast, woven, or embroidered in the Middle Ages, it is highly question-

139 **Entry into Jerusalem.** *Detail of*
stained-glass window at Saint-Etienne,
Bourges, France, thirteenth century.

able that all such associations entered a medieval mind. Without convincing documentation of a specific creature's iconographic meaning, we would do well to respect the advice of Emile Mâle and "resist the temptation to explain the inexplicable."[89]

The various creatures encountered in the pages of this book have been selected to accord with my efforts to examine the sources, science, and symbolism of medieval animal imagery. These examples represent only a small fraction of the wealth of animal imagery created during the Middle Ages. Working in all available artistic media throughout Western Europe, medieval artists created fascinating beasts for almost every available environment—certainly for the secular arena and, in spite of Bernard of Clairvaux, in great abundance for the religious sphere, too.

Perhaps more important than the number of animals is the extraordinary variety of species in the medieval artists' menagerie. Although the fundamental and universal appeal of animal imagery can be seen in the art created during many eras and in many areas, it is especially in late medieval Western Europe that the fascination with endless species of fantastic fauna surpassed that of any other time or place. The artists of the Middle Ages did their utmost to augment Mother Nature's efforts in creating the medieval menagerie.

140, *etail of Heraldic Lions with Banners from the Prayer Book of Bonne of Luxembourg, fol. 15r. Follower of Jean Pucelle. French, Paris, c. 1345. Cloisters Collection, The Metropolitan Museum of Art, New York.*

NOTES

INTRODUCTION (pages 13–18)

1. This is explained in the *Life of Adam and Eve* and the *Book of Jubilees (Little Genesis)*, both written in the first century A.D. and popular in later years. See Francis Klingender, *Animals in Art and Thought to the End of the Middle Ages*, ed. Evelyn Antal and John Harthan (Cambridge, Mass.: M.I.T. Press, 1971), p. 154, on this and many other aspects of the use of animals in medieval art.

2. Three categories, consisting of domestic animals, monsters, and pairs of confronted animals of Eastern origin, were suggested for the many carved creatures at Autun Cathedral by Abbé Denis Grivot in *Le Bestiaire de la Cathedrale d'Autun* (Lyon, France: Editions Ange Michel, 1973).

3. See Mia Gerhardt, "The Ant-Lion," *Vivarium* 3 (1965): 1–23.

CHAPTER ONE (pages 19–64)

4. On antique survival in the Middle Ages see, among others, Charles H. Haskins, *The Renaissance of the Twelfth Century* (Cambridge, Mass.: Harvard University Press, 1982); Jean Seznec, *The Survival of the Pagan Gods* (Princeton, N.J.: Princeton University Press, 1972); R. R. Bolgar, ed., *Classical Influences on European Culture, A.D. 500–1500* (International Conference, King's College, Cambridge, 1969), Proceedings (Cambridge, England, 1971); Jean Adhémar, *Influences antiques dans l'art du Moyen Age français* (London: Studies of the Warburg Institute, 1939).

5. See F. Brommer, *Heracles: The Twelve Labors of the Hero in Ancient Art and Literature* (New Rochelle, N.Y.: A. D. Caratzas, 1986).

141 ***pes. Marble capital from cloister of Saint-Michel-de-Cuxa, France, mid-twelfth century. Cloisters Collection, The Metropolitan Museum of Art, New York.***

■ ***Saint Bernard of Clairvaux complained about the sculptures of "filthy apes" in the cloisters.***

6. Virgil, Aeneid, VI, 285–89, trans. R. Fitzgerald (New York: Vintage Books, 1983), pp. 169–70.

7. A rare appearance of sphinxlike creatures in the Middle Ages is seen on a capital at Chauvigny, although the necks are much longer than in known antique examples. Illustrated in W. Anderson, *The Rise of the Gothic* (New York: Dorset Press, 1988), fig. 63.

8. The second century A.D. Greek author Lucian, in his *Zeuxis*, 3, wrote about the artist of this name (active c. 425–400 B.C.) who painted a family of hippocentaurs consisting of a father and a mother nursing two babies. This picture greatly impressed people because it depicted a female, whereas centaurs are usually shown to be a male species. A rare medieval depiction of a centaur nursing appears on a capital at Iffley church, illustrated in G. C. Druce, "Some Abnormal and Composite Human Forms in English Church Architecture," *Archaeological Journal* 72 (1915): 135-86, pl. XIII, no. 2. On the centaur see Peter von Blanckenhagen, "Easy Monsters," *Monsters and Demons in the Ancient and Medieval Worlds* (Mainz: Verlag Philipp von Zabern, 1987), p. 87f.

9. Centaurs appear with special frequency in eleventh- through thirteenth-century French sculpture. See V. H. Debidour, *Le Bestiaire Sculpté du Moyen Age en France* (Paris: Arthaud, 1961), figs. 53, 106, 334, 335, 337, 404. For German centaurs, see Wera von Blankenburg, *Heilige und Dämonische Tiere* (Cologne: Wienand Verlag, 1975), figs. 61, 63, 64, 68, 83, 89, 90. For English centaurs, see M. D. Anderson, *Animal Carvings in British Churches* (Cambridge, England: Cambridge University Press, 1938), p. 80. Also J. Bayet, "Le symbolisme du cerf et du centaure à la porte rouge de Notre-Dame de Paris," *Revue archéologique* 44 (1954): 21–68, figs. 4–6, pp. 52, 53, 55.

10. This emphasis on the East as the source of the exotic and unusual also appears in a treatise on monstrous beings known as *The Marvels of the East*, written c. 1400, which was very popular in the Middle Ages. The original title and author are unknown. See Rudolph Wittkower, "Marvels of the East," *Journal of the Warburg and Courtauld Institutes* 5 (1942): 159–97.

11. See the examples in Debidour, *Bestiaire Sculpté*, figs. 4, 342, 417; Druce, "Abnormal and Composite," p. 152f.

12. See S. W. de Rachewiltz, "De Sirenibus: An Inquiry into Sirens from Homer to Shakespeare" (Garland, Ph.D. dissertation, Harvard University, 1983); Denise Jalabert, "De l'art oriental antique à l'art Roman: Recherches sur la faune et la flore Romane II, les Sirènes," *Bulletin Monumental* 95 (1936): 433–71; Druce, "Abnormal and Composite," 169f.

13. The sirens in the *Worksop Bestiary* face each other and raise their tails. They are similar to those in a Spanish fresco from the monastery of San Pedro de Arlanza, Burgos provence, c. 1220–1230, now in the Cloisters. In this fresco the role of the siren as songstress probably is related to the music-making scene beside the sirens in which a donkey plays a stringed musical instrument and a fox and a goat seem to dance to the music (Cloisters Collection, 31.38.2a).

14. As translated from a twelfth-century Latin bestiary in Cambridge University Library, II.4.26, by T. H. White, in *The Book of Beasts* (New York: Dover Publications, 1984), pp. 134–35.

15. See Klaus Niehr, "Horaz in Hildesheim— Zum Problem einer mittelalterlichen Kunsttheorie," *Zeitschrift für Kunstgeschichte* I (1989): 1–25.

16. Philippe de Thaon, *Le Bestiaire*, ed. Emmanuel Walberg (Paris: H. Möller, 1900; reprinted Geneva, 1970).

17. On the problem of the siren as woman plus bird and/or fish, see Druce, "Abnormal and Composite," p. 171f. Also Edmond Farel, "La queue de poisson des sirènes," *Romania* 74 (1953); 443–506, and Carol S. Pendergast, "The Cluny Capital of the Three-Headed Bird," *Gesta* 27, nos. 1–2 (1988): 33–36.

18. According to Richard de Fournival, the siren is guilty for luring the man to his death, but the man is also guilty for trusting the siren. *Master Richard's Bestiary of Love and Response*, trans. J. Beer (Berkeley: University of California Press, 1986), p. 10f.

19. Ambroise Paré, *On Monsters and Marvels*, ch. 35, first published 1573, trans. J. L. Pallister (Chicago: University of Chicago Press, 1982), p. 107.

20. See G. Benwell and A. Waugh, *Sea Enchantress* (New York: Citadel Press, 1965).

142 **omposite Creatures, *detail from* Prayer Book *of Bonne of Luxembourg, fol. 315r. Follower of Jean Pucelle. French, Paris, c. 1345. Cloisters Collection, The Metropolitan Museum of Art, New York.***

21. Anthony Weir and James Jerman, *Images of Lust* (London: B. T. Batsford, Ltd., 1986), pp. 48–53; Clause Gaignebet and Jean-Dominique Lajoux, *Art profane et religion populaire au Moyen Age* (Vendôme: Presses Universitaires de France, 1989), pp. 142–49; John Block Friedman, "L'Iconographie de Venus et de son miroir à la fin du Moyen Age," *Erotisme au Moyen Age* (Montreal: Les Editions de L'Aurore, 1977), pp. 51–82. A different sort of fish-woman appears in the ancient tale of beautiful but unfortunate Scylla. Although loved by Glaucus, she does not return his affection. Circe, however, does love Glaucus and, jealous of his attraction to Scylla, pours a magic potion into the water in which Scylla swims. As explained in Ovid's *Metamorphoses* (XIII, 895–967; XIV, 59–67), Scylla is changed into a monster with fish tails for legs and dogs all around her lower body. But Ovid is kinder to Scylla than Homer, for Homer's description in the *Odyssey* (XI, 85–110; XII, 33–259) made her totally terrifying, with twelve feet and six heads. Representations of Scylla seem to have been rather rare in antiquity and in the Middle Ages. See Pendergast, "Cluny Capital," pp. 35–36, figs. 8–10.

22. See John Boardman, "'Very Like a Whale': Classical Sea Monsters," and Peter von Blanckenhagen, "Easy Monsters," in *Monsters and Demons,* pp. 73–84 and pp. 85–94, respectively.

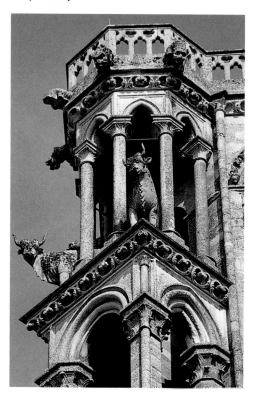

143 **B**ulls. *Tower on west facade of Cathedral, Laon, France, early thirteenth century.*

■ *The fame of Laon's towers derives from the sculpted bulls that decorate them. Construction of the cathedral atop the ridge of a hill was made possible by bulls who hauled the building materials. While saints were honored by placing their images along the church roof line, at Laon bulls occupied a similar position of prestige.*

164

23. The dragon is the attribute of saints Margaret of Antioch, Martha, George, Michael, Cado, Clement of Metz, Florent, Germanus of Auxerre, Keyne of Cornwall, Maudet, Paul, Philip the Apostle, Romanus, Sylvester, and others.

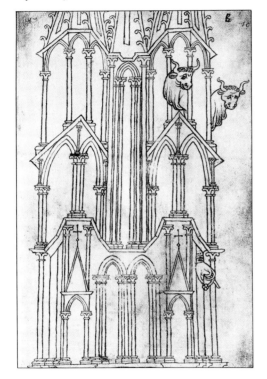

24. See Jacques Duchaussoy, *Le Bestiaire divin ou la symbolique des animaux* (Paris: Le Courrier du Livre, 1972), p. 27, on the dragon as a demon.

25. Although the story of the dragon has been used to discredit Saint George's very existence, the dragon slaying was actually a late medieval addition to George's resumé.

26. See Ronald Sheridan and Anne Ross, *Gargoyles and Grotesques: Paganism in the Medieval Church* (Boston: New York Graphic Society, 1975).

CHAPTER TWO (pages 65–102)

27. White, *Book of Beasts*, pp. 92, 93.

28. Some of the tales associated with Aesop predate his era (sixth century B.C.), while other portions were added later; "Aesop's" fables are a compilation of the ideas of many people and times; no definitive text exists, although the earliest extant text dates from the first century A.D.

29. The first complete and widely influential version of Aristotle's *History of Animals* was that with commentaries by Averroes, translated into Latin by Michael Scot before 1220 at Toledo, Spain.

144 *ower of Laon Cathedral, sketchbook, pl. xix. Villard de Honnecourt. French, 1230s. Bibliothèque Nationale, Paris, Ms. Fr. 19093.* ■ *Villard is reported to have said: "J'ai été en beaucoup de terres, nulle part n'ai vu plus belles tours qu'a Laon." ("I have been in many lands, nowhere have I seen more beautiful towers than at Laon").*

30. See Xenia Muratova, "Problèmes de l'origine et des sources des cycles d'illustrations des manuscrits des *Bestiaires*," *Actes du IVe Colloque International "Epopée animale, fable et fabliau*," Evreux, September 8–11, 1981 (Paris: Publications de l'Université de Rouen, 1984).

31. See Otto Homberger and Christoph von Steiger, *Physiologus Bernensis* (Basel: Alkuin Verlag, 1964). Another very early illustrated bestiary is that made in the tenth century, probably in the north of France, from the monastery of Saint Lawrence near Liège, now in Brussels,

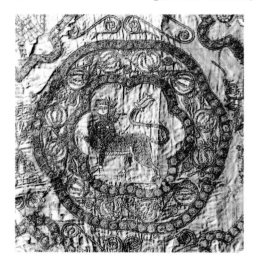

Bibliothèque Royale, MS. 10066–77.

32. On the bestiary, see Willene B. Clark and Meradith T. McMunn, *Beasts and Birds of the Middle Ages: The Bestiary and Its Legacy* (Philadelphia: University of Pennsylvania Press, 1989), in which the need to examine bestiary imagery in other media is noted, p. 6. Clark and McMunn, pp. 205–14, provide a bibliography of bestiary studies since 1962 as a continuation of the bibliography in Florence McCulloch, *Mediaeval Latin and French Bestiaries* (Chapel Hill: University of North Carolina Studies in the Romance Languages and Literatures, no. 33, 1960, revised 1962). Accessible translations of medieval bestiaries are White, *Book of Beasts*, noted above, and *Le Bestiaire*, trans. Marie-France Dupuis and Sylvain Louis (Vesoul: Philippe Lebaud Editeur, 1988), a translation into modern French of a late twelfth- or early thirteenth-century English bestiary known as the Bestiary Ashmole 1511, Oxford, Bodleian Library. For a sampling of bestiary imagery see Ann Payne, *Medieval Beasts* (New York: New Amsterdam Books, 1990).

33. See Dupuis, *Le Bestiaire*, pp. 179–89.

34. White, *Book of Beasts*, pp. 199–200.

35. Ibid., p. 33.

 145 **uman-Headed Lion.** *Spanish, tenth–twelfth century. Embroidery on silk. Musée Historique des Tissus, Lyon, France.*

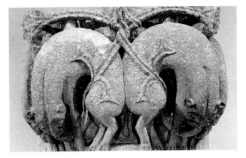

36. Ibid., p. 21. See Duchaussoy, *Bestiaire Divin*, pp. 190–92, on the symbolism of the unicorn.

37. By 1600 there were over a dozen "unicorn horns" in Europe and England. If they were not narwhal tusks they were likely to have been ivory or stag horn.

38. A rhinoceros was first brought to Europe (to Lisbon) in 1498. Albrecht Dürer made his famous engraving of this rhinoceros in 1515 from a sketch he had been sent.

39. Nona C. Flores, "The Mirror of Nature Distorted: The Medieval Artist's Dilemma in Depicting Animals," *The Medieval World of Nature*, ed. Joyce E. Salisbury (New York: Garland Press, 1992) discusses the elephant and the willingness with which baseless "facts" were accepted in the Middle Ages because they were written by authors whose authority was unquestioned.

40. White, *Book of Beasts*, p. 80.

41. Ibid., pp. 50-51.

42. See McMunn, "Bestiary Influences in Two Thirteenth-Century Romances," in *Birds and Beasts*, pp. 134–43. The Mycenaeans and Assyrians carved huge stone lions as gateway guardians and the Greeks used images of lions as grave markers and/or guardians. The hieroglyphic texts carved on the Egyptian temple of Horus at Edfu in the Ptolemaic period call the lion "the king of the beasts."

43. Philippe de Thaon's bestiary relates the lion to Christ, saying: "The lion in many ways rules over many beasts, therefore is the lion king. . . . The lion signifies the son of Saint Mary; he is the king of all the people." In John's Revelation 5:5, Christ is seen as "the Lion of the tribe of Judah."

44. White, *Book of Beasts*, p. 13.

45. The story of the tigress deceived by the glass ball as her cub is stolen is portrayed in the famed mosaics at the Piazza Armerina in Sicily, created in the third or fourth century. See Florence McCulloch, "Le tigre et le miroir—La vie d'une image, de Pline à Pierre Gringore," *Revue des Sciences Humaines* 33 (1968): 149–60.

146 *igers. Limestone capital from apse of San Martin, Fuentiduena, Segovia province, Spain, second half of twelfth century. Cloisters Collection, The Metropolitan Museum of Art, New York; on loan from the Spanish Government.*

46. The bestiary relates Pliny's story of King Garamantes, who was taken prisoner and sold into slavery. Two hundred of his dogs then raised an army, crossed enemy lines, and rescued their master. Also derived from Pliny is the story of the dog who went with his master to prison and remained faithful to him even after his execution. People felt pity for the dog and brought him food, which the dog brought to the mouth of his dead master. When the body was thrown in the Tiber, the dog tried to keep it afloat as long as he could.

47. White, *Book of Beasts*, p. 67.

48. Samuel A. Ives and Hellmut Lehmann-Haupt, *An English Thirteenth-Century Bestiary: A New Discovery in the Technique of Medieval Illumination* (New York: H. P. Kraus, 1942); R. W. Scheller, *A Survey of Medieval Model Books* (Haarlem: De Erven F. Bohn, 1963). A fine example of a complete late medieval pattern book of animal studies to be used by other painters is that by the northern Italian painter and architect Giovanni de'Grassi (d. 1398). Grassi used these sketches in a prayer book with animal images in the borders illuminated for Gian Galeazzo Visconti (now in the collection of the Visconti de Modrone, Milan). Grassi made studies from the menagerie at the Visconti Palace, Pavia. His workshop illustrated a reference book on natural history with animal drawings (now in the Biblioteca Casanatense, Rome).

49. *Scriptores Historiae Augustae (Augustan History)* 33, I, 2.

50. This included a fascination with the destruction of the animals. When the Romans exhibited unusual animals such as lions, leopards, and bulls for the purpose of public entertainment, the slaughter of the animals was likely to be the grande finale. Only on rare occasions did the public seem to object to such carnage. See J.M.C. Toynbee, *Animals in Roman Art and Life* (Ithaca, N.Y.: Cornell University Press, 1982), p. 17f.

51. Klingender, *Animals in Art,* p. 449.

52. Another page from Villard de Honnecourt's sketchbook depicts and describes the technique used to train a lion. The inscription translates: "I will tell you of the training of the lion. He who trains the lion has two dogs. When he wants to make the lion do anything, he commands him to do it. If the lion growls, the man beats the dogs. When the lion sees how the dogs are beaten he becomes afraid.

His courage disappears and he does what he is commanded." This training method was not Villard's invention; rather, he relates a technique that was considered effective in his time.

53. On the *Chronica Majora* see Suzanne Lewis, *The Art of Matthew Paris in the Chronica Majora* (Berkeley: University of California Press, 1987), pp. 212–16.

54. White, *Book of Beasts*, pp. 103–52. Similarly unscientific writing on birds is provided by the English Benedictine monk Alexander Neckam (1157–1217). Neckam's two books on natural history, *De naturis rerum* and *De laudibus divinae sapientiae*, are concerned with known facts and their moral interpretation. The assumed behavior of different kinds of birds is interpreted as a mirror of human life—not necessarily flattering to the humans. In the kingdom of birds, the birds of prey form the ruling class with hawks and falcons the barons, ravens the clergy, and cocks the doctors of the church. The cuckoo represents avarice.

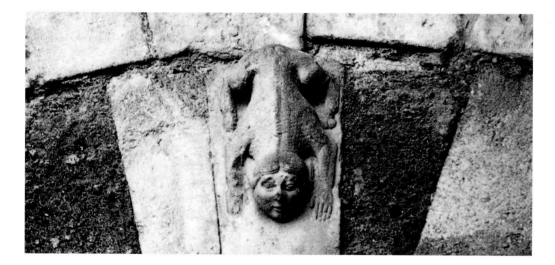

147 **rog with Woman's Head. Relief from** *cloister at Notre-Dame, Le Puy, France, twelfth century. ■ In an era when women were viewed as a source of temptation, this frog, symbol of sin, was given a woman's head.*

55. For several examples of medieval bird imagery, see Dom Claude Jean-Nesmy, *Bestiaire Roman*, trans. by E. de Solms (Pierre-qui-Vire: Zodiaque, 1977), figs. 17–32, pp. 86, 95.

56. Other illuminations in this manuscript also demonstrate the increasing realism of animal representation. The *Meeting of the Magi* (fol. 51v) and the *Adoration of the Magi* (fol. 52r) include images of camels based upon one owned by the duke and cheetahs drawn from one received by the court of Burgundy from Gian Galeazzo Visconti, the duke of Milan. Jean de Berry's brothers, King Charles V and Duke Philip the Bold, also kept menageries that may have provided artists with models of exotic animals. Millard Meiss, *French Painting in the Time of Jean de Berry: The Limbourgs and Their Contemporaries* (New York: Thames and Hudson, 1974), I, p. 156. Jean Longnon and Raymond Cazelles, *The Très Riches Heures of Jean, Duke of Berry* (New York: George Braziller, 1989), p. 193, figs. 48, 49.

CHAPTER THREE (pages 103–159)

57. See the discussion in Emile Mâle, *The Gothic Image: Religious Art in France of the Thirteenth Century* (New York: Harper and Row, 1972), pp. 27–63, and the papers published in *L'Uomo di Fronte al Mondo Animale nell'Alto Medioevo*, April 7–13, 1983 (Spoleto: Settimane di Studio del Centro Italiano di Studi sull'Alto Medioevo, 1985).

58. See Conrad Rudolph, *The "Things of Greater Importance": Bernard of Clairvaux's Apologia and the Medieval Attitude Toward Art* (Philadelphia: University of Pennsylvania Press, 1990), pp. 11–12.

59. In the same vein, earlier lines in this letter read, "O vanity of vanities, but no more vain than insane! The Church is radiant in its walls and destitute in its poor. It dresses its stones in gold and it abandons its children naked. It serves the eyes of the rich at the expense of the poor. The curious find that which may delight them, but those in need do not find that which should sustain them." Rudolph, *Bernard . . . Apologia*, p. 11. A somewhat different, but also negative, view on the possibility of symbolic interpretation was expressed centuries earlier by Saint Basil the

Great (c. 329/30–379), bishop of Caesarea. Saint Basil favored interpreting the Bible literally:

> There are those truly, who do not admit the common sense of the Scriptures, for whom water is not water, but some other nature, who see in a plant, in a fish whatever their fancy wishes, who change the nature of reptiles, and of wild beasts to suit their allegories. . . . For me grass is grass; plant, fish, wild beast, domestic animal, I take all in the literal sense. (Basil, *Hexaemeron*, ix, I. Schaff and Wacc, eds., *A Select Library of Nicene and Post-Nicene Fathers of the Christian Church* [Grand Rapids: W.B. Eerdmans, 1978], VIII, p. 101.)

60. See Creighton Gilbert, "A Statement of Aesthetic Attitude Around 1230," *Hebrew University Studies in Literature and the Arts* 13 (Autumn 1985): 125–52.

61. The French theologian Honorius of Autun, writing in the late eleventh and early twelfth centuries, says there are several reasons for a painting: as adornment for the building, as the book of the layman, and to recall the lives of earlier people.

62. Although their sex is clearly differentiated, all are maned. In the Middle Ages the presence of a mane merely meant that the animal was a lion, and was used for both the male and female of the species.

63. This shield is said to have been hung around the neck of Geoffrey Plantagenet by his father-in-law, Henry I of England, when he knighted Geoffrey in 1127. See Sir Anthony Wagner, *Heraldry in England* (London: Penguin Books, 1946), p. 5.

64. Aulus Gellius, V, 14; Aelian, *De Natura Animalium*, VII, 48. Seneca, *De Beneficiis* II, 19, I, writing about the lions in the amphitheater, says that on one occasion when the human victims entered the arena, a lion recognized one man as his former keeper and protected him from being attacked by the other lions.

65. The idea that the lion can be good or evil is seen in Aesop. In the tale of "The Lion and the Mouse," the lion lets a mouse go free from under his paw and later the lion, caught in a net, is set free by the mouse, who gnaws through the ropes, thus repaying the lion's generosity to the weak. In the fable of "The Lion and the Horse," however, the lion claims

to be a doctor—a trick to enable him to eat the horse. But when the lion examines the horse's foot, the horse kicks the lion on the forehead, repaying evil with evil.

66. Mâle, *Gothic Image*, pp. 43–45, analyzed the Amiens *Beau Dieu*, explaining that the information in the bestiaries was known to the clergy via Honorius of Autun's *Speculum Ecclesiae (Mirror of the Church)*, written between 1090 and 1120, which includes a sermon for Palm Sunday that derives from Psalm 91.

67. A striking demonstration of the perpetuation of the griffin's physical form over many centuries and miles, albeit with losses in strength and refinement, is provided by comparing the griffins on a stone door lintel from Hatra in northern Iraq (second century A.D.) to the griffins on an Italo-Byzantine

marble relief from Sorrento (eighth to ninth century), both in the Metropolitan Museum of Art, New York (32.145 and 30.30, respectively). See also Debidour, *Bestiaire Sculpté*, p. 216f.

68. The griffin's popularity in the Middle Ages is demonstrated by the celebrated *Bayeux Tapestry*, the borders of which include fourteen griffins and twenty-nine winged lions. The winged lions appear in association with William the Conqueror, whose triumph over Harold at the battle of Hastings for the crown of England is related in the tapestry. David J. Bernstein, *The Mystery of the Bayeux Tapestry* (Chicago: University of Chicago Press, 1987), p. 127, n. 10; p. 128.

69. See Duchaussoy, *Bestiaire divin*, pp. 178–82, on the griffin.

70. Although Mandeville says he started his travels in 1322, they were not described in writing until 1356 and his book was published in 1356 or 1357. The great popularity of the *Travels* is demonstrated by the number of copies made in the fourteenth and fifteenth centuries. But the author's honesty has been questioned to the extent of doubting that he ever traveled at all. Highly derivative, Mande-

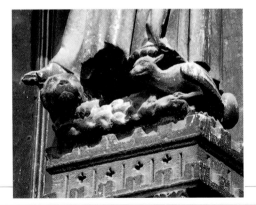

148 Adder, Basilisk, Lion, and Dragon
from Beau Dieu base, trumeau on west façade,
Cathedral, Amiens, France,
first half of thirteenth century.

ville took whole portions from earlier authors and his information is ultimately rooted in classical sources. See *The Travels of Sir John Mandeville,* trans. C.W.R.D. Moseley (Harmondsworth, England: Penguin Books, 1987). See also J. Kràsa, *The Travels of Sir John Mandeville* (New York: George Braziller, 1983), for recent commentary on the manuscript in the British Library.

71. Beer, *Master Richard's Bestiary,* pp. 15, 16.

72. Pink carnations are symbols of pure love, fidelity, and marriage, and are often used in betrothal and marriage portraits. Their presence here supports one of the interpretations of the tapestries discussed below.

73. This tapestry includes the same peculiar animal that appears in the tapestries of the other senses, now presumably older as his beard has grown and his hooves have formed; he lacks only the horn of the full-grown unicorn.

74. In this tapestry some of the subsidiary animals wear collars or belts and one of the monkeys is chained to a roller. They are pets or part of a menagerie.

75. An unusually large number and variety of animals are depicted for mille fleur tapestries. Besides the unicorn, lion, rabbit, and dog, the series includes the cheetah, lion cub, panther, wolf, goat, genet, lamb, monkey, duck, falcon, heron, magpie, and partridge.

76. The recurring coat-of-arms with three crescents displayed by the unicorn and the lion is that of the Le Viste family of Lyon. Whichever interpretation is correct, it may be presumed that the tapestries were commissioned by a member of the Le Viste family. They may have been made for Jean IV Le Viste, a French statesman in the royal administration, active 1482–1500. The tapestries would then date between 1484, the year of the death of his father, after which Jean could carry the family arms, and before 1500, the year in which Jean died. However, it has also been argued that the tapestries were made as a wedding gift from Antoine Le Viste, a French statesman (c. 1470–1534), to his fiancée Jacqueline Raguier (active c. 1500–d. 1520). Jacqueline is his *Seul Désir.* See Alain Erlande-Brandenburg, *The Lady and the Unicorn* (Paris: Editions de la Réunion des Musées

Nationaux, 1989); Fabienne Joubert, *La tapisserie médiévale au Musée de Cluny* (Paris: Réunion des Musées Nationaux, 1988), pp. 66–84; Carl Nordenfalk, "Qui a commandé les tapisseries dites de la 'Dame à la Licorne'." *Revue de l'art* 55 (1982): 53–56.

77. To the left of the fountain is a medlar tree, also represented in the third and fourth tapestries of the series. The prominence of the medlar tree is explained by the medieval belief that its fruit, crushed and mixed with wine, provides an antidote for poison, much like drinking from a unicorn-horn beaker. Medlar fruit, although easier to acquire than unicorn horn, is probably comparable in efficacy.

78. The question of whose wedding remains unanswered, although the monogram that appears in the corners and centers of the tapestries and even on the dogs' collars is the chief clue to the owner's identity. The *A* and inverted *E* have been said to be the monogram of Anne of Brittany, whose marriage to Louis XII of France took place on January 8, 1499, which corresponds with the date the tapestries were woven. But it has been observed that in Anne of Brittany's monogram the knot in the cord linking the *A* and *E* is not tied as it is in the tapestry, and that the knot is not always tied in the same manner in all the tapestries, largely discrediting the theory. See Margaret B. Freeman, *The Unicorn Tapestries* (New York: Metropolitan Museum of Art; E. P. Dutton, 1983), pp. 155–74.

79. The spotted animal in the tapestry is presumably a leopard, although the leopard and panther were confused in the Middle Ages. The bestiaries say the leopard is the result of adultery between a lioness and an animal called a pard. Pliny says that a female pard mated with a lion will have the same result. The bestiaries explain that the leopard is gentle, intelligent, kind, beautiful, and has breath so sweet that other animals are attracted. The leopard is loved by all animals except the dragon—a symbol of Satan. Thus, the leopard represents the lover as well as Christ. Alternatively, the leopard, as the result of an impure and adulterous union, represents corruption and sin. The small animal in the tapestry is a weasel or genet—the two were confused in the Middle Ages. The bestiary compares the weasel to an elongated mouse and explains that she is so skilled in medicine that if her babies are killed she

can make them live again. The courageous weasel is the enemy of serpents—i.e., of Satan. As noted in Chapter 2, the bestiaries' understanding of the weasel's reproductive habits questioned whether conception or birth was through the ear or through the mouth. The hyena, according to the bestiary, is a cross between a dog and a cat; it is neither male nor female but can change from one sex to the other and back again. Living in tombs and devouring dead bodies, it represents wickedness, fierceness, and filth. But the hyena has redeeming qualities, for its spleen can restore eyesight and the stone in its eye (the yena), if kept under the tongue, allows one to foresee the future. The stag is a symbol of fidelity. He is an enemy of serpents, and if he is ill he will eat the serpent because the poison is healing to him. This information goes back to Pliny and was repeated thereafter, as was the claim that stags are charmed by the music of flutes (Pliny, VIII, 50). The bestiary says that burning a stag's horn will keep snakes away, and that the horn on the right side of the stag's head is useful for healing. The marrow will cure fever, it claims, asserting that stags never become feverish, and eating venison gives immortality.

80. The number of dogs has been multiplied in this tapestry. Part of the pleasure of the medieval stag hunt was felt to be the noise of the baying hounds. A fourteenth-century French author writes: "When the hounds give tongue, never has man heard melody to equal this. No Alleluia sung in the chapel of the king is so beautiful . . . as the music of hunting hounds. . . . The large ones sing tenor and the others counter-tenor." At the top of this tapestry are the initials *F* and *R* tied together. They are not part of the original tapestry, and whose initials these are remains uncertain. This sky, like the sky in the other tapestries, is also recent work.

81. The stag hunt was also considered very dangerous, for the stag could mortally wound a hunter, giving rise to the saying "After the boar, the doctor, and after the stag, the bier."

82. The location of this scene in an enclosed garden, a symbol of the Virgin Mary, reinforces the religious interpretation of the unicorn as Christ and the virgin as the Virgin Mary. This interpretation comes from the Song of Solomon 4:12, "a garden enclosed is my sister,

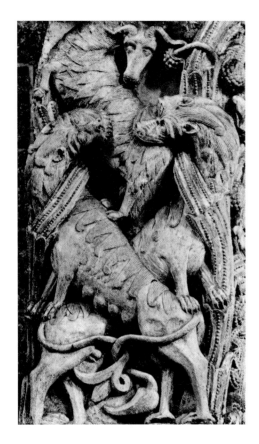

my spouse." The white roses symbolize Mary's purity and virginity, the red roses her charity and suffering. Mary is described as the rose without thorns and Bernard of Clairvaux describes Mary as "the violet of humility, the lily of chastity, the rose of charity."

83. Perhaps some indication of the loss can be gained by looking at the Cluny tapestry of *The Sense of Sight* (figure 117) and picturing it in reverse. It was common practice in the Middle Ages to take someone else's composition, reverse it, and reuse it. Because tapestries are woven from the back, the front is also a reversal of the design the worker sees.

84. The unicorn is transported by a powerful horse. Great value was attached to horses in the Middle Ages as a means of transportation, as a source of power, and as indispensable in battle. Further, the bestiary explains: "When their master is dead or dying, horses shed tears—for they say that only a horse can weep for man and feel the emotion of sorrow." The bestiary offers some practical advice: "the pace of a horse is judged by the twitching of the ears, its spirit from the twitching of the limbs," and: "The deeper a horse dips its nostrils when drinking, the better his prospects as a sire." But we are told that "The virility of

149 **L**ions Attacking Goat. *Fragment of a trumeau (?), Sainte-Marie, Souillac, France, twelfth century.*

horses is extinguished when their manes are cut" (White, *Book of Beasts*, pp. 86–87)—the equestrian equivalent of Samson and Delilah.

85. Above the monogram in the lower right is a little frog, noted for an aphrodisiac bone in his left side.

86. The pomegranate was known in the West because it was imported by the traders from the East. But the tree was unknown to the weavers who invented this fantasy.

87. See Mâle, *Gothic Image*, pp. 36–37. Jerome also said that the four animals represent the four powers of the soul (intellect, will, appetite, and conscience) as well as the four elements of the universe, and signify the fullness of knowledge.

88. The image of the sheep and shepherd appears in Matthew 9:36, Mark 14:27, John 10:1-16, and elsewhere.

89. Mâle, *Gothic Image*, p. 48.

177

 150 **pocalyptic Monsters.**
Tympanum at Saint-Pierre,
Beaulieu, France, 1125–50.

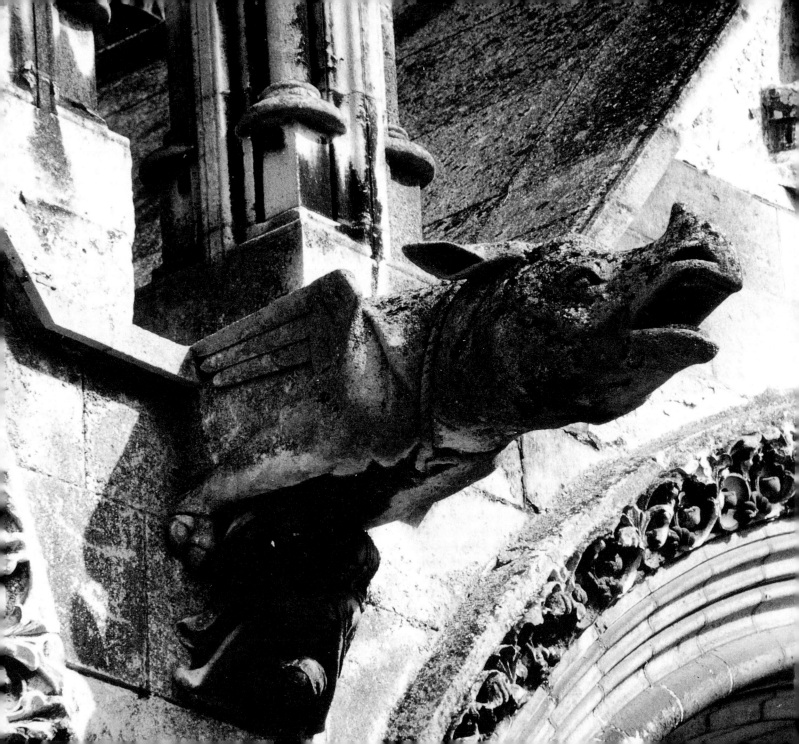

INDEX

 inged Rhinoceros Gargoyle.
West facade of Cathedral, Laon,
France, early thirteenth century.

180

181

PHOTO CREDITS